iPhone Obsessed
Photo Editing Experiments with Apps

by Dan Marcolina

iPhone Obsessed: Photo Editing Experiments with Apps
Dan Marcolina

Peachpit Press
1249 Eighth Street
Berkeley, CA 94710

510/524-2178
510/524-2221 (fax)

Find us on the Web at www.peachpit.com
To report errors, please send a note to errata@peachpit.com
Peachpit Press is a division of Pearson Education

Project Editor: Susan Rimerman
Developmental/Copy Editor: Peggy Nauts
Proofreader: Scout Festa
Indexer: Karin Arrigoni
Production Editor: David Van Ness
Interior Design and Composition: Marcolina Design Inc.
Cover Design and Image: Marcolina Design Inc.

ISBN-13: 978-0-321-77162-9
ISBN-10: 0-321-77162-1

9 8 7 6 5 4 3 2 1

Printed and bound in the
United States of America

Dedication

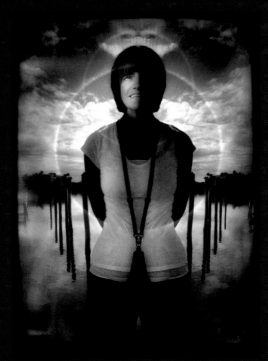

For Denise, Who Completes My Circle.

 I would like to dedicate this, my first book, to my wife and business partner, Denise, who creates the space and supplies the inspiration for me to explore my visual obsessions with controlled abandon. And to my son, Danny, and daughter, Dana, who have waited so many times for me to catch up with the family after being distracted with some picture opportunity. Their pictures now inspire me.

APP TAG

SCAN THE TAG TO SEE THE FAMILY GALLERY

Table of Contents

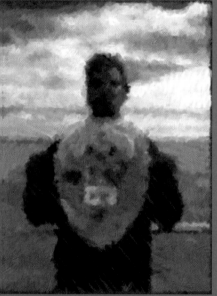

APP SketchMee (CHAPTER 7)

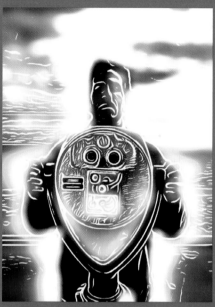

APP ToonPaint (CHAPTER 5)

APP FX Photo Studio (CHAPTER 12)

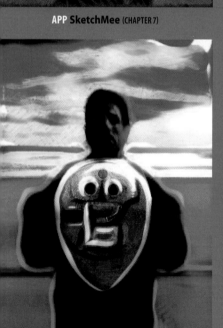

APP TiltShift (CHAPTER 4)

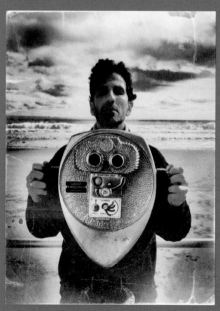

APP PictureShow (CHAPTER 11)

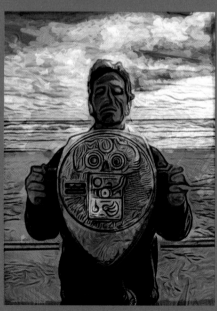

APP Artist'sTouch (CHAPTER 7)

Introduction I Am Obsessed

I am obsessed. I am obsessed with my iPhone. Not for making calls, listening to music, or even taking pictures. No, mostly I'm obsessed with processing images with apps!

Collecting and combining apps to explore new image iterations. Dozens of iterations. Turning snapshots into statements. With the right subject, shot and processed with just the right intent, you can transform your image into an illustration of an idea.

A blurred image may just perfectly clarify your idea. The trick is to put effectiveness before effects. How do you set the tone of an image for its best impact? Think of this book as an alchemist's journal of creative elixirs, as we will be discovering the results of cross-mutating apps with a variety of image types. I have looked at most of the photography apps in iTunes and have boiled them down to my favorites. You can be certain that the 47 or so included in this book have useful or artistic merit of some kind.

With the right subject, shot and processed with just the right intent, you can transform your image into an illustration of an idea.

I've been a designer and photographer for over 25 years, and I'm known for my skills with image manipulation, but this new mobile platform has challenged me to try things I would never have attempted in my traditional workflow. And now I have been liberated to add new techniques to my everyday design work.

Some images in the book may not be completely successful. But each one shows some promise or possibility that may help you break through with something even better.

How the Book Works

I have broken down the postprocessing into common categories like blurs or grunge or HDR. At the beginning of each chapter I outline my favorite apps in that category with a short description of each app's main strengths.

All of the app descriptions and many other pages have another layer of virtual information called an iObsessed Tag. Get app demos, image tips, and pic galleries.

After each intro you will see many examples to show off the chapter's techniques. Examples also include the original image and the steps of the processing. Since this book is really about combining different techniques, the steps often include apps from other chapters, which are referenced so you can find them quickly.

Also, all of the app descriptions have another layer of virtual information called an iObsessed App Tag, shown to the left. When you scan the tag with the free Microsoft Tag Reader (http://gettag.mobi) on your iPhone, additional information on the app will be revealed. It includes a short overview demo video by the author that helps you understand the app's possibilities. Also included are links to the developer's Web site and iTunes download link and related photography galleries.

APP TAG

TIP TAG

PIC TAG

Many other pages have Tip Tags, which when scanned will reveal a video tip on how the image was processed. Pic Tags give you a gallery of related information or insights into a process.

This book is for iPhone 3GS or later users, but you can also use an iPod Touch 4 for shooting and processing with these apps.

In the final chapter you will discover a gallery of additional experimental images and unusual apps, including iPad only apps. There is also a Links Glossary of all the apps on page 174 with the Web addresses for app demos, for easy reference or for those of you without an iPhone.

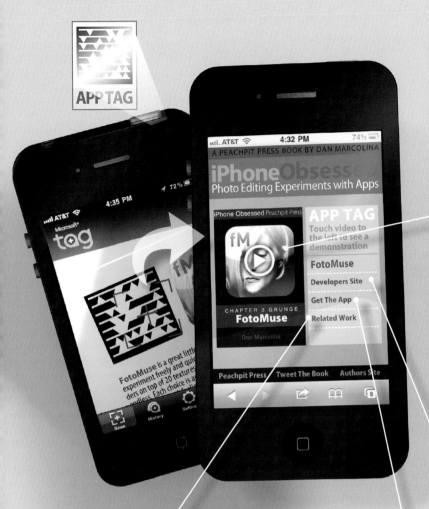

A video tour of each app When you touch the large image, up pops a full-screen video demo by the author of each of the 47 apps, showing tricks and hidden features.

Expand your viewpoint Here you are linked to the author's personally selected galleries to view his latest experiments or other related info.

iTunes download link From this master control panel you can immediately jump to the iTunes download link and get the app.

Link to the developer's Web site Touch to go directly to the latest news and updates. Get tutorials and see samples of your favorite apps.

Chapter 1 Capturing the Mobile Moment

I take lots of images since my iPhone is always in my pocket. Most of them are not worth showing. It is usually the moment that sneaks up on you that brings together the ingredients of a memorable image. It is then that you must quickly figure out the best way to frame the moment, because it can be gone in a flash.

What Is the Mobile Moment?
The circumstances that cause me to pull out my iPhone.

1 The pure graphics of a scene, like contrasts in color or scale, unique shapes, or great light.

2 The human moment…the gesture of a body against a background, a tension or decisive moment, an expression or certain reflective gaze.

3 Images that suggest stories or an unexpected mystery, an ironic twist, or a humorous juxtaposition.

It is usually the moment that sneaks up on you that brings together the ingredients of a memorable image.

4 Then there is the "personal image," which really can't be explained adequately with words. It might happen because of one of the above, along with personal emotional overtones that color the perception. These types of images may or may not be successful to a larger audience. The ones that are successful contain universal overtones that spark some unconscious engagement.

In each of the cases above your final decision on how to frame the picture—what to include and what not to include, what angle, high or low—should help define your objectives.

Creating the Tone with Framing
My process on framing the story in the moment.

What to include in the frame and what not to include: It is that decision that really defines why still images can be more powerful than seeing the whole scene as in video.

Framing directs your story. The elements that remain force the viewer into completing the sentence. It is the design within the frame that can give it its power.

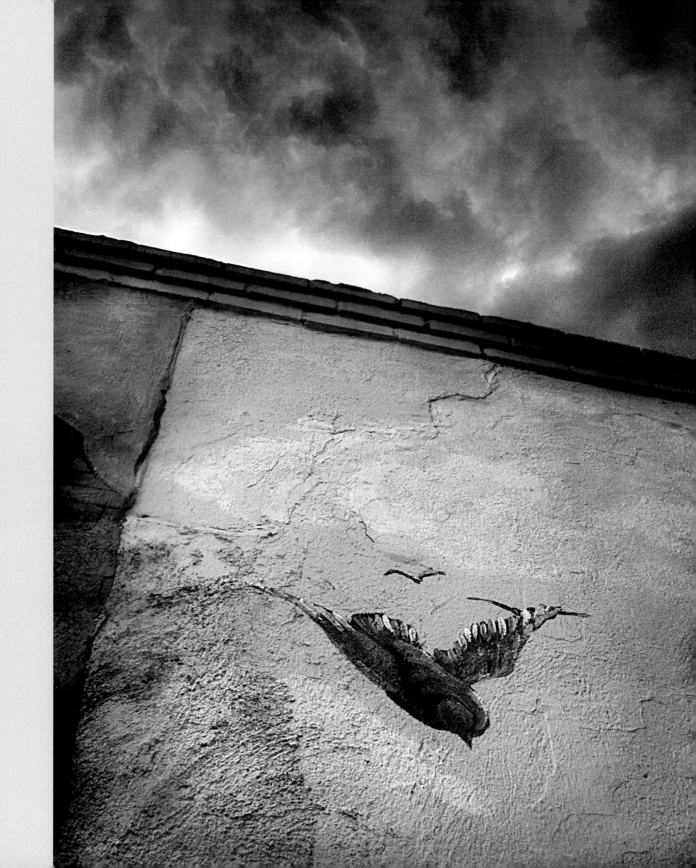

Since the screen is so large on the iPhone, larger than on most any other camera, it is a great asset for quickly deciding your framing when shooting. Here is my process.

Just Shoot It...Then Think About It

The opportunity may be gone in a second, such as the goat may move, the body gesture of your subject may shift, the light may fade. Often it's the unconscious reaction to a moment that is the most honest and makes the most impactful picture. It is really easy to overthink a shot.

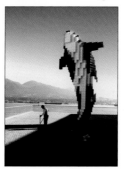

It is easy to overthink a shot. Once you start thinking about it the picture moment may lose its charm.

Once you start thinking about it the picture may lose its charm. But although the first impression may work best, you should always follow up with a more conscious set of angles.

What is the angle of the shot, high or low? How does the perspective on the scene help support your story line? If the shot is at eye level it gives the viewer a feeling of first person, as though it is something he is experiencing from his perspective. The low shot gives drama or power to the scene because it makes it seem grander and it is not a typical view of the world. A shot from above brings out the graphic form of things. Shapes stand out against the background of the floor or ground.

Horizontal, vertical, or square. Ask yourself, is this story more dynamic if I see more space to the left and right or can I make it more concise by seeing more height? And of course a square image might be better.

When I shoot with the iPhone I shoot more vertically, but when I shoot with my DSLR I shoot mostly horizontally. I suspect it has mostly to do with what position is more comfortable to shoot from with each device. You can hold and shoot in the vertical mode more easily with the phone. But I also think of an app-manipulated image as being more editorial, more illustrative, and best framed as a full page, like the right-hand side of the magazine spread—so for me that means shooting vertically with the phone.

And the horizontal view of a 35mm is more true and honest as a fine art print. The square, on the other hand, has a neutral effect on the attitude of what is in the image, and it feels most honest and graphic. But it also speaks of times gone by when film from cameras was mostly square, and you can conjure up the retro Polaroid memories. So if you think about the image as a square before you shoot it, frame the subject and imagine the top and bottom of the frame cropping out. In other words, pull back a bit.

Consider the volume or third dimension. Pictures of course are 2D but how elements within the picture overlap and the sense of scale that the foreground and background bring to the viewer's experience are also important. The positive and negative space set a rhythmic tone.

Light is probably the most important directional element in a composition. It gives pictures their soul.

Look closely at how things overlap and check that no alignment in the image feels distracting or uncomfortable or unresolved. The image should direct the viewer to the action, purifying the experience.

Seeing the light. Light is probably the most important directional element in a composition. It gives pictures their soul. A few seconds difference between the time you see the picture and take the picture can make or break the image.

Bright is not always best. Very flat, gray light can help a picture work. It can make objects flatter and merge together. The image can hold more tone since the shadows are not black and highlights are not blown out.

Soft rim light can reveal objects in a subtle way, informing the viewer of which objects to look at first and hiding unnecessary ones.

Hard light can bring out texture and pattern and attract a viewer simply by its design interest but then surprise her when she realizes what she's looking at.

A dash of light or beam or pool of light can bring drama and power to a picture. It can model an object or person into an icon. You can define your point of view within a single glance. These moments are the most fleeting, as the slivers of light can occur from a unique combination of the angle of the sun, the time of day, and the position of the object—even a temporary reflection from some off-camera object.

A picture can really change its attitude by exposing for highlights, midtones, or shadows.

Backlighting or a light burst directly into the camera can add drama. Also, the silhouetting and rim light can give the image a graphic or bold effect. Just be careful not to expose the sensor to super bright light too long, which can damage it.

Focus and exposure. Although right now you cannot control the depth of field when taking mobile pictures (you can fake it later), on a close-up shot within 3 to 12 inches of an object you can actually force the background out of focus. By touching the screen on a foreground object you can see the background go out of focus. Also, touching the screen to set the exposure can help in postprocessing. A picture can really change its attitude by exposing for highlights, midtones, or shadows.

Although exposing for the midtones gives you the most flexibility in post, exposing for shadows or highlights might give the best interpretation of what you are reacting to.

The Mobile Distinctions and Previsualizing the Post

All this thinking can really drain the spontaneity out of the iPhone experience. So don't think too much, because although it's the simplicity and lightweight shooting that make mobile photos so intuitive it is the postprocessing that can help reinforce your intent. Sometimes these strengths easily outweigh the skills of a bulky DSLR.

With a DSLR your reaction can be delayed.

■ When you pull open your camera bag's Velcro flap, the noise brings unwanted attention to you.

■ What lens should be used? Wide angle, telephoto?

■ What aperture should you use to get the best depth of field?

■ What shutter speed and what ISO; is your lens cap on?

■ Will you get mugged when people see your expensive camera? (OK, you could still get mugged for your iPhone—but it's not as likely!)

So as much as I encourage you to think about framing, remember you can take care of some of that later with an app. Take pictures from the heart. You always have your phone, so grab it and shoot.

If the postprocessing is done with your "story" in mind, it can bring drama and symbolism to everyday imagery.

As you learn what you can do with apps you can start to previsualize the processed image. This knowledge will inspire you to take certain pictures you may not have considered. A scene may be really interesting but the light is not right…just shoot it and use LensFlare in post. If the colors are clashing but the shapes are interesting, shoot it and convert to black and white or desaturate all but one color with Iris Studio. If the picture is too flat, shoot it and make it flatter with ToonPaint or push the saturation and blur with TiltShift. If the picture is just boring, try randomizing it with PictureShow—it might bring out an unexpected intent.

Some subjects are best shot with a DSLR, like images with fine detail, action, low light, or faraway subjects. But I think lots of situations are better rendered with the low-fi qualities that mobile brings. It is an opportunity to bring an editorial angle to your images. If the postprocessing is done with your "story" in mind, it can bring drama and symbolism to everyday imagery. Your images become more iconic and more illustrative. The following pages represent my journey of exploring the edges of this new medium.

Chapter 2 Straightforward

Scan the tags next to the app icons and see a short video from the author explaining each app's key concepts. In addition, you will have access to the iTunes download link and developer's Web site. The tag urls are also included in the Links Glossary on page 174.

This chapter captures essential setup and finishing tools. They can clean up images and sharpen, brighten, or merge layers. At their basic level these apps add punch to a straight shot. Some of them can certainly do more than just functional tasks, and you may want to explore all aspects of them. The way I work, though, is I view the iPhone as the main program and the individual apps as plug-ins within that program; thus I prefer using dedicated effect apps to focus on one task. This routine somehow clarifies my process.

 Photoshop Express allows you to drag your finger across your image and see effects like sharpening, exposure, and blurring in real time. I use it because it is the fastest picture prep app around. And since it uses Adobe's image algorithms I am confident of the output quality.

 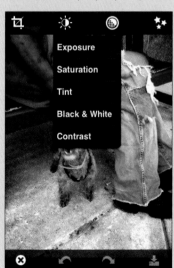

Quickness is key Use simple gestures to quickly edit and share photos from your mobile device.

Top features Crop, straighten, rotate, and flip; exposure, saturation, tint, black and white, and contrast; sketch, soft focus, and sharpen; effects and borders.

Access Your entire online photo and video library are at your fingertips. You can upload and manage your Photoshop.com account directly from your device.

 Iris Studio is a very complete image enhancement application. I use it like I might Photoshop. When I have a poorly exposed image I have complete control of exposure and color in the shadows, highlights, and midtones. It also allows me to creatively blend two images with the layers mode.

A complete suite Edit your images with the same ease and accuracy you're used to having on your Mac or PC.

27 filters You can brighten up your night images with artificial flash, creating depth-of-field effects or converting your portrait to a sketch.

Layers support You can easily create self-blends, or even combine multiple captures into a composite, along with masking and blending images.

 DXP was the only app of its kind for a long time. It allows me to quickly blend two images using 18 blend modes. As with Photoshop's layer modes you can place, for example, a picture of handwritten text over another image with the multiply setting to make it look as though it was actually written on the picture.

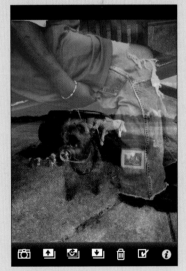

Essential effects This app has become essential to pulling off many of my images. I primarily use hard light, multiply, and screen settings.

Over 18 blending modes Having many blending modes allows you to experiment with different looks. A lot of the time I am pleasantly surprised by the results.

Add a mask The app also allows you to cut through an image with a mask. The mask can be another photo where the dark areas cut through more than the light areas.

 Tiffen PhotoFX has a mind-boggling array of image altering effects. Although it can be a bit overwhelming I find it very well executed. Tiffen's long history of making glass filters for traditional photography means it really understands what kind of effects are useful. From adding film grain or changing day to night, you have full control.

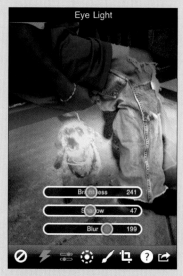

76 filters It offers 878 presets organized in 8 filter groups. The film lab, tints, image fx, and special fx are among my most-used.

Unlimited flexibility Try one of 62 color or black-and-white film looks. Choose from 27 grain presets to simulate popular motion picture film stocks or 18 special effects.

Be selective Selectively apply filters by painting a mask. And build up effects one at a time without tedious, picture-damaging repeated saving.

 Perfectly Clear can perform miracles in just a few seconds on poorly exposed images. It does a great job balancing out a picture in the areas of brightness, sharpness, color, and noise. A lot of the time I try it first on under- or overexposed images, or I run it at the end of my processing to brighten up an image that has gotten too dark.

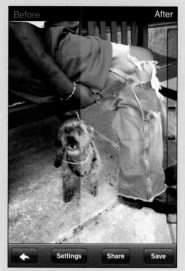

Proven technology This app has many patented algorithms and ten years of scientific research behind it. Athentech's photo products are licensed worldwide.

Full control There are two presets that you can use to correct your photo, or you can easily and quickly tweak your image by adjusting six characteristics.

Noise removal technology The app provides smooth low-light, high-ISO performance by offering fully automated noise detection, analysis, and removal.

 Touch Retouch is a lot like content aware fill in Photoshop. I use it to clean up an image that has an annoying object or imperfection in it that is drawing too much attention. I am more likely now to take a picture if something is a bit out of place because I know I can easily correct it.

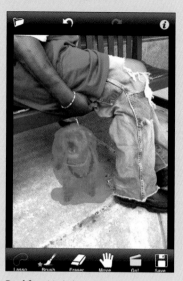

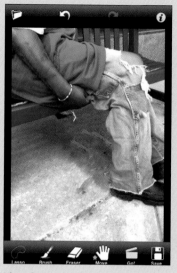

Clean up A revolutionary application that lets you remove unwanted content or objects from your photos, using just your finger.

Real fast Mark the items you want taken out of the snapshot with the brush or lasso tool and hit Go.

Ideas for use Remove wires from your picture, remove your shadow from a self-made picture, remove ghosts and flare, smoothen and retouch the face.

 TouchUp Studio has a unique combination of intuitive functions. I use it for selectively brushing in contrast, exposure, and sharpness into an image. I also use it to softly blend two differently processed versions of the same image back together and bring back parts of the original photo through a blurred or painted version.

Unique app I know of no other app with the key abilities to selectively add effects, multiple textures, and various tints in different opacities by finger brushing.

Expose your image You can change the brush size and effect strength to add many different exposure effects as seen above.

Color and texture Mix your own color to use in your photo. Choose between 12 textures to emboss or reveal. The montage button lets you combine images.

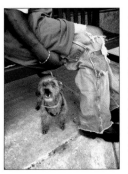

Fierce Dog / Process

THE MOMENT This image was the very first photo that I took with my new iPhone 3GS. As I walked out of the Apple store I turned and there was this "fierce" picture. The combination of colors and textures along with the contrast in scale of the small dog and a large man caught my eye. I turned quickly, asked the man if I could photograph his dog, and before I got a surprised answer yes, I was gone with this image.

THE PROCESSING I wanted to darken and saturate the man and the background but wanted to brighten and clarify the dog. In the mobile app world there are only a few options for selectively altering image areas. I used TouchUp Studio here, but some new choices might be Iris Studio or Filterstorm.

Scan this tag for a review of best camera-use techniques and apps.

APP TAG

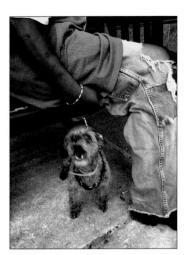

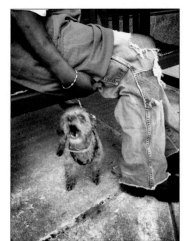

Photoshop Express I gave the shot needed sharpening and saturation. Next, I created two versions, one exposed for the man and a lighter one for the dog.

TouchUp Studio Putting the darker image over the lighter one, I was able to brush in through a mask to reveal the lighter dog area and selectively darken the edges.

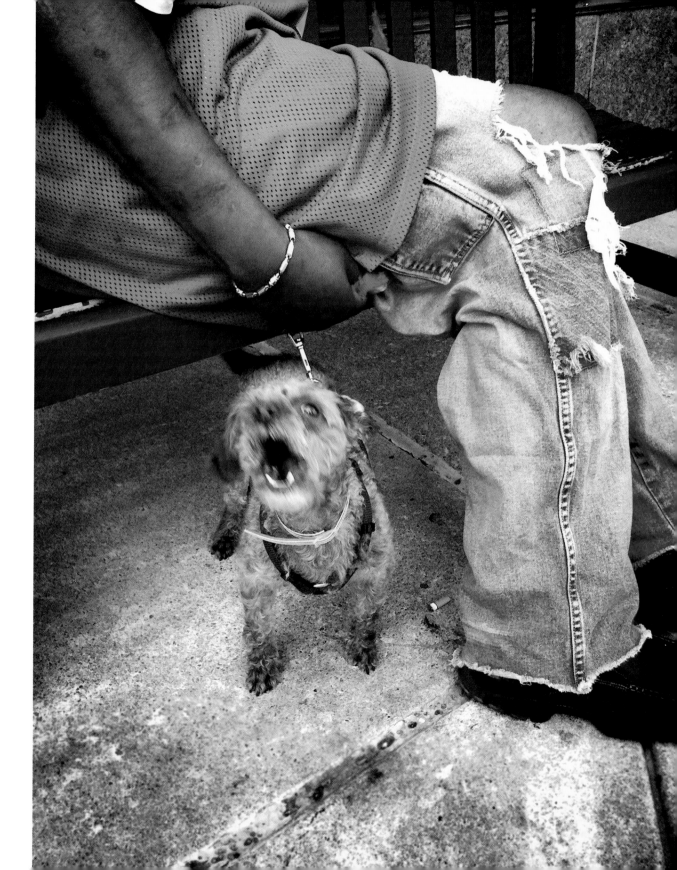

CMYK Sample Book **Photoshop Express** Sharpen and brighten.

Shut Out **Iris Studio** Sharpen, brighten open shadows, and selectively saturate colors.

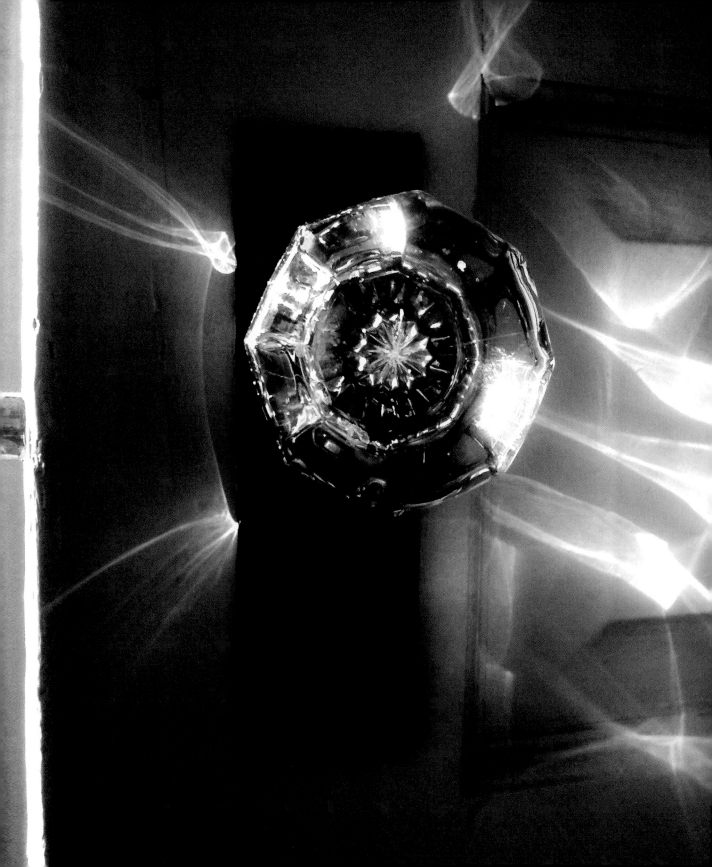

End of the Hall / Process

THE MOMENT Always keep your senses open because certain pictures only occur at certain times of the day and even certain times of the year. What you see at the left only occurs between about 4:30 and 5:30 in the afternoon in July and August, just at the end of the hall in my office. Depending on the angle of the door and time of day the pattern is always different. Thus I have shot this in many different ways. **THE PROCESSING** I converted the image to black and white to bring emphasis to the light pattern. And like I would in Photoshop, I layered a blurred darker version with a brighter sharp one using the lighten mode in Iris Studio. **SCAN THE TAG TO SEE THE PROCESS**

TIP TAG

STEP 1 Photoshop Express Create a dark, sharp black-and-white version.

STEP 2 Photoshop Express Create a darker, soft-focus version.

STEP 3 Iris Studio Overlay blurred image on top of sharp version using soft light mode.

TIP TAG

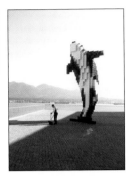

Pixelated Whale / Variation

THE MOMENT During an early-morning walk through Vancouver, Canada, I came across this scene. The shootable moment lasted for just a few seconds, and I took the base shot and then ran into a better position—close enough but not so close that I would disturb the sweeper. It is the low sun and long morning shadows that make it work. **THE PROCESSING** My favorite variation is shown at the right. It is processed with PhotoFX. The app allowed me to control, with a mask, the tone of the sky along with contrast and saturation. **SCAN THE TAG TO SEE THE PROCESS**

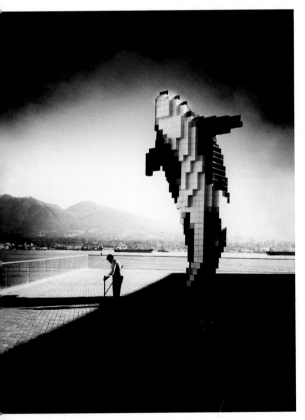

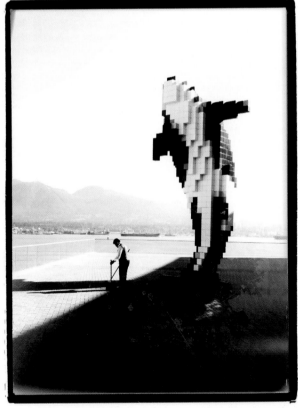

STEP 1 PictureShow (CHAPTER 11) Cinema and vignette setting.
STEP 2 PlasticBullet (CHAPTER 6) Random exploration.

PictureShow (CHAPTER 11) Bleach setting with "old fashion" border and painting drop noise.

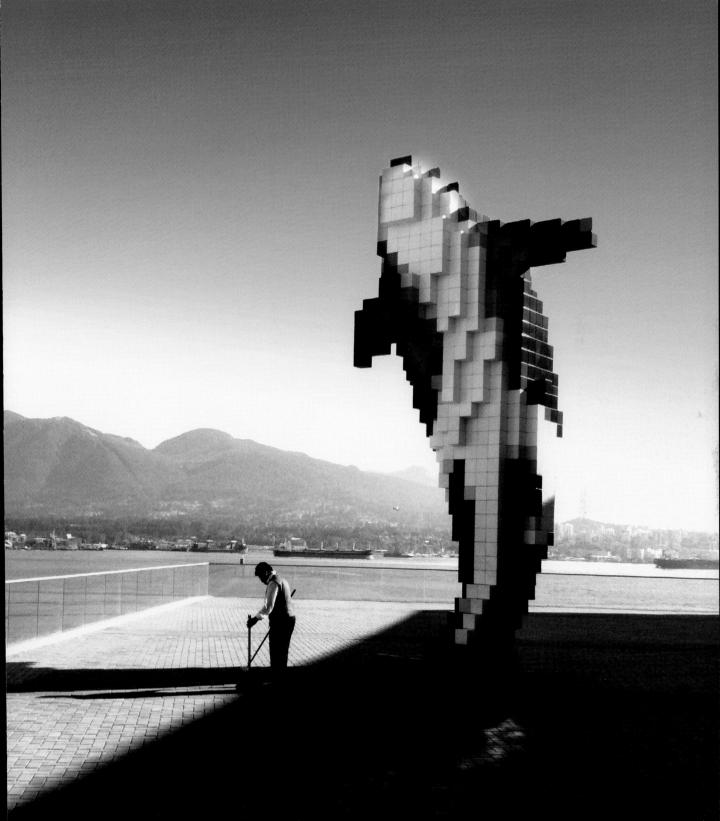

Scruffy and Froggy

Iris Studio Open shadow areas, bring down highlights, increase saturation and sharpness.

PIC TAG *The strength of shooting with a DSLR is usually complex pattern, color, and light with lots of details, and that forms a big part of my more traditional photography. Scan the tag to see my DSLR work.*

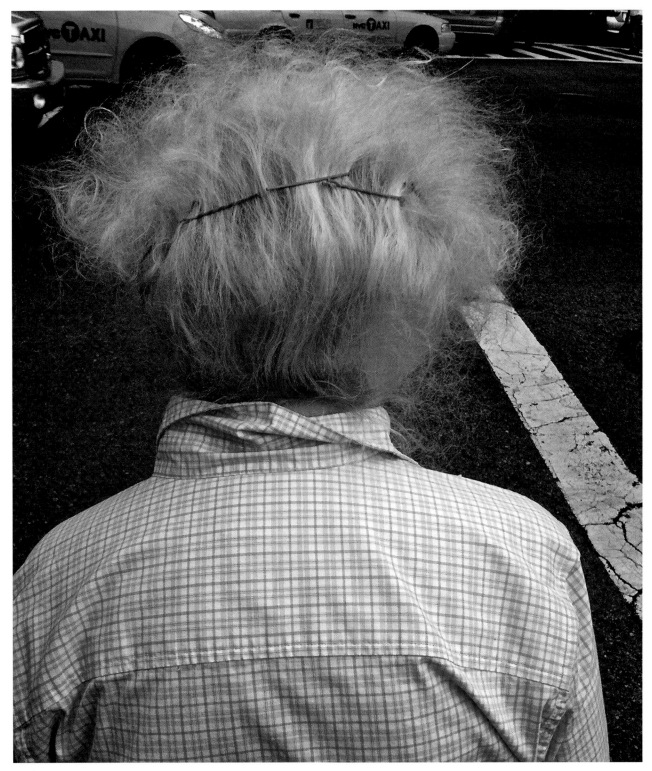

Bad Hair Day **Iris Studio** With levels, darken overall and sharpen and add saturation to the blue, then dark vignette the edges.

Spring Approaches **Iris Studio** Open the shadows and add saturation to the yellow; with levels, darken overall and sharpen.

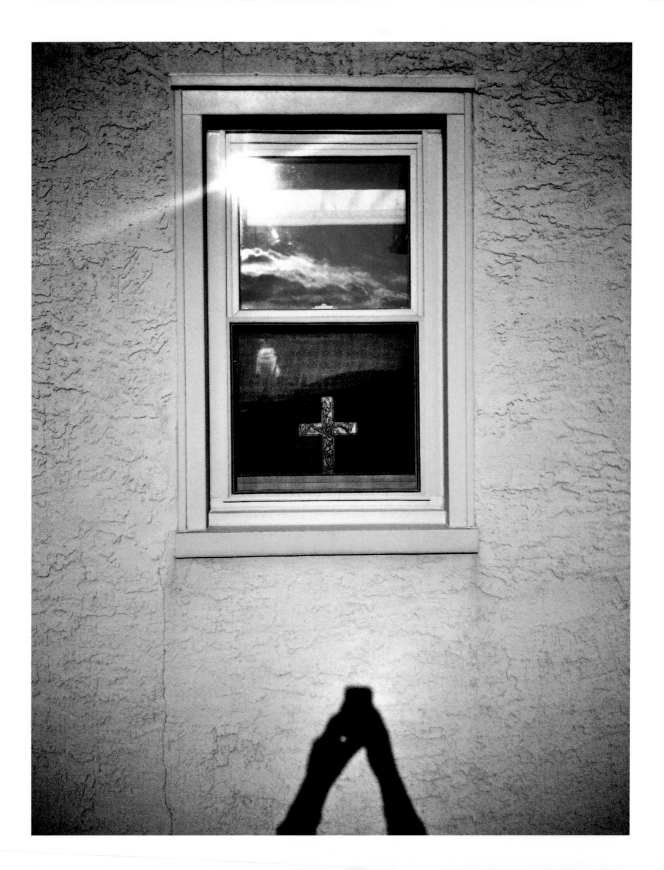

Reaching / Process

THE MOMENT Take some time at lunch and walk somewhere. You have your whole office in your phone anyway—you won't miss anything! I discovered this shot a couple of blocks from my office down an alleyway. I had to hold the phone way above my head to get just the right glint of sunlight off the window. I was hoping that no one was home because what do you say? "I liked the glint of sun and the way the gold cross called out to me"?

THE PROCESSING The key to this image was opening up the shadows in the window in a natural way, along with adding color and sharpness to the cross. TouchUp Studio allows very intuitive selective retouching.

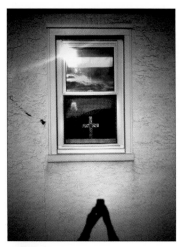

Perfectly Clear Open the shadows and bring up saturation and sharpness automatically.

PhotoFX Add blue in the window with the polarize filter and brush in the bright gold on the cross through a mask.

Touch Retouch Remove the black blemish on the left side of the wall by quickly circling it with the marquee tool.

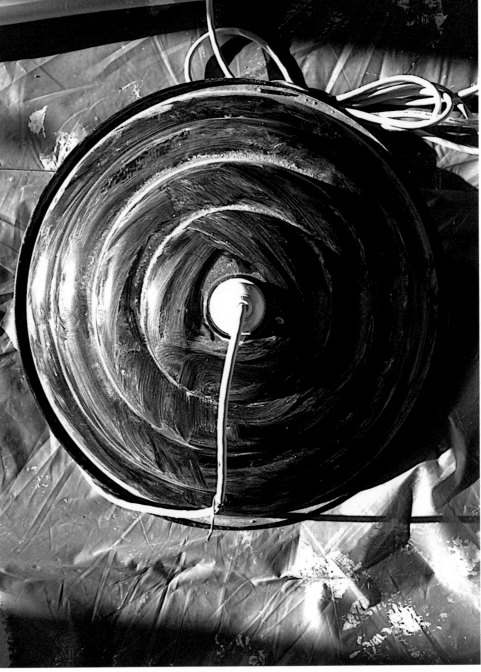

Renovations 1 **Photoshop Express** Convert to hard black and white plus sharpen.

Renovations 2 **Photoshop Express** Convert to hard black and white plus sharpen.

Chapter 3 Grunge

Scan the tags next to the app icons and see a short video from the author explaining each app's key concepts. In addition, you will have access to the iTunes download link and developer's Web site. The tag urls are also included in the Links Glossary on page 174.

So the cleaner and sharper the pictures, the more I want to grunge them up. I'm not quite sure why this scratching, blotching, and desaturation of a shot makes it more appealing to me. Perhaps it takes the story to another era or changes the narrative of the setting, adding an air of mystery or desolation. Not all images work with this approach; the ones that seem to are bold graphically to start with and already have a nostalgic or lonely, isolated feeling to them.

 FotoMuse is a great little find. It allows me to experiment freely and quickly with over 22 borders on top of more than 23 textures. The combinations are endless. Each choice is artfully done with a real variety of natural-feeling distortions. They don't seem forced or out of place.

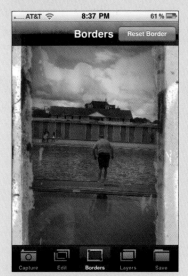

Add a frame Mix your images with artifacts from old photos, vintage edged film, and many other options.

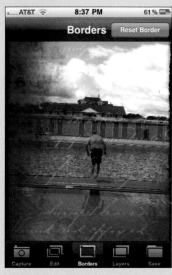

Add snap in a snap First you can increase the contrast and saturation of your image in the edit mode.

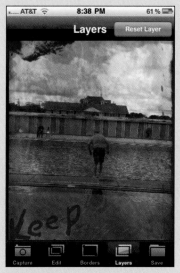

Borders on genius You can swipe any of 22 borders—mixed with any of 23 textures—over your image.

 PicGrunger is an app that quickly brings a distinct attitude to my pictures. I usually use it as a final step in the process, but consider it, for example, before you add a paint effect. This app makes pictures feel as if they were printed years ago and just rediscovered in the bottom of an old box.

Add a frame This is a really nice app. It works quickly and has enough variation to keep things fresh. The results can give an image a new attitude.

Frame your subject Try acid, aged, bleach spill, blotched, cracked, creased (my favorite), scratched, scuffed, sponged, streaked, and weathered.

Color me palooza You can vary the overall color and contrast of the effect in six ways along with adding a border.

 PhotoCopier copies the color style and texture of old painting masters, movie classics, and photography icons onto your images. I use it to explore tonal and textural possibilities of an image. There are hundreds of presets to play with. It always surprises me how just color and texture can dramatically change the feeling of a picture.

More than noise With this app you can not only control the texture but also the color tones and contrast, giving your image many different "feels."

Image formulas The DNA of hundreds of different paintings, movies, photo- graphs, and "historical processes" can be applied to your images.

A time machine Try one of 30 historical processes, like Ambrotype, Cyanotype, Liquid Emulsion, Kallitype, Palladium, Salt Print, Vandyke, and Wet Plate.

TIP TAG

Summer's Last Dive / Process

THE MOMENT This picture was taken on the last weekend of the summer at the Jersey shore. Right off the beach is this private throwback swim club. As we were walking past the gate to the pool my friend pointed with amazement at this guy about to take his last plunge for the season. It all came together pretty quickly, and just before our diver left the edge of the pool the camera came on and I snapped the image. You can see another image from this vantage point in Chapter 7. **THE PROCESSING** My objective with any picture processing is to follow the image's tone or intent. In this case I wanted to accentuate the nostalgic tone and the feeling of the end of summer, making it feel like a warm memory. I attempted to achieve this by altering the colors and giving it a glowy quality in CameraKit and adding the old, worn look in FotoMuse. **SCAN THE TAG TO SEE THE PROCESS**

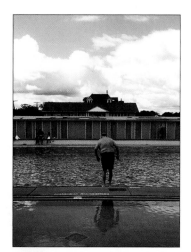

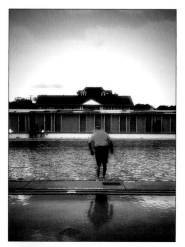

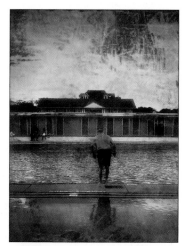

Photoshop Express First I cropped and straightened the image and added a bit of saturation and sharpness.

CameraKit I then developed the image with the classic film, vignetting, and flash on settings. The soft focus was level 3 and I push-processed it to level +2.

FotoMuse I added various combinations of borders and texture layers until it felt right. I often save many variations to look over later before I choose one.

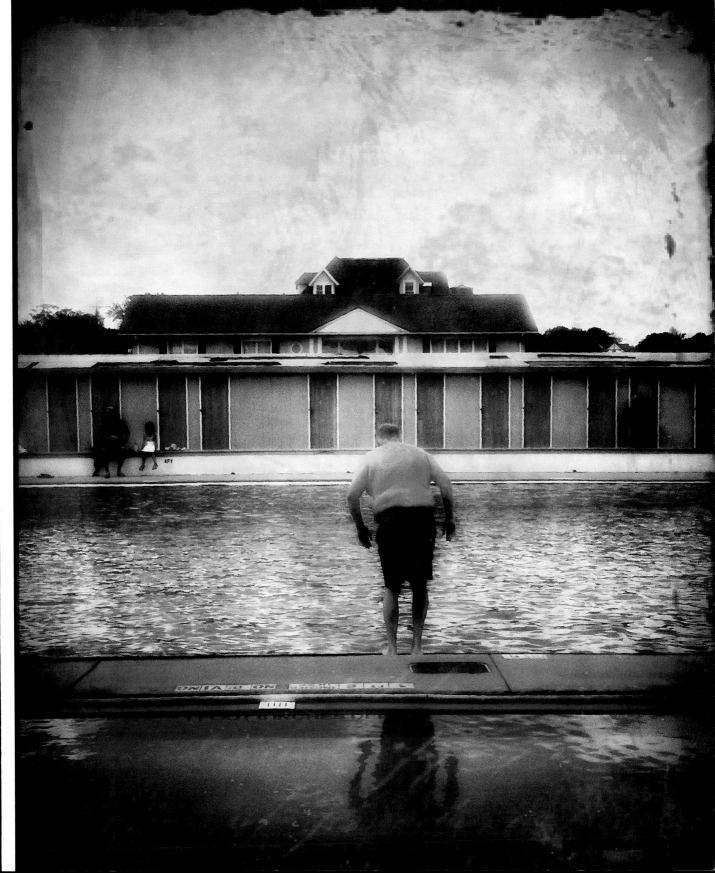

STEP 1 BlurFX (CHAPTER 4)
Blur with median setting
and saturate. Brush the
original image back into
the center.

STEP 2 LoMob (CHAPTER 11)
Add Polaroid border and
change color tones.

STEP 3 PicGrunger
Add scratches.

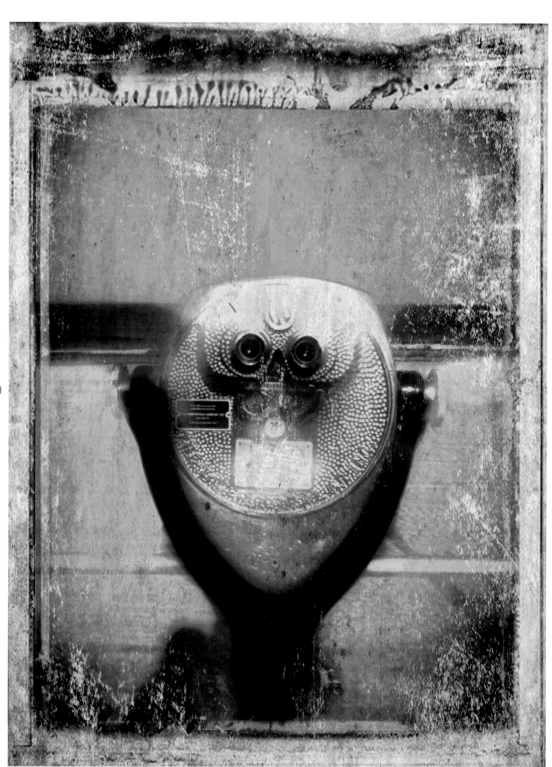

PIC TAG

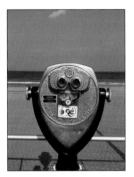

Avon by the Sea / Variation

THE MOMENT Just up the boardwalk from the previous image is this classic viewing device, the same one that's on the cover. It is a great mobile subject as it is very graphic with lots of nostalgic energy that can be channeled into different iterations. **THE PROCESSING** My favorite variation is shown on the left. The addition of the Polaroid border in LoMob really pushed the retro tone. **SCAN THE TAG TO SEE OTHER VARIATIONS OF THIS SCENE AND MORE BEACH RELATED IMAGES**

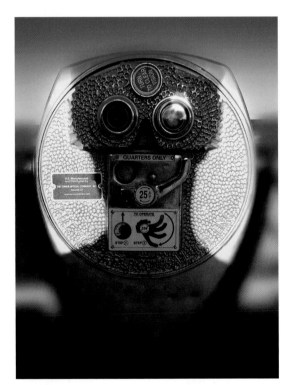

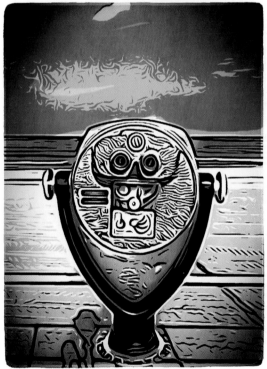

STEP 1 FilmLab (CHAPTER 6) Use film setting orange-blue.

STEP 2 BlurFX (CHAPTER 4) Selectively blur and saturate around device.

STEP 1 ToonPaint (CHAPTER 5) Create black line work and loosely paint in flat colors in sky and sand.

STEP 2 LoMob (CHAPTER 11) Use the postcard 3 effect on the original.

STEP 3 DXP (CHAPTER 2) Combine steps 1 and 2 using hard light.

Spider-Man Sat Here

STEP 1 Photoshop Express (CHAPTER 2)
Crop square plus brighten and sharpen.

STEP 2 BlurFX (CHAPTER 4)
Selectively blur foreground and add
saturation around the chair.

STEP 3 FotoMuse
Add border and texture.

*Look down the side streets
when you have time. These
are the pictures most people
with cameras don't see.*

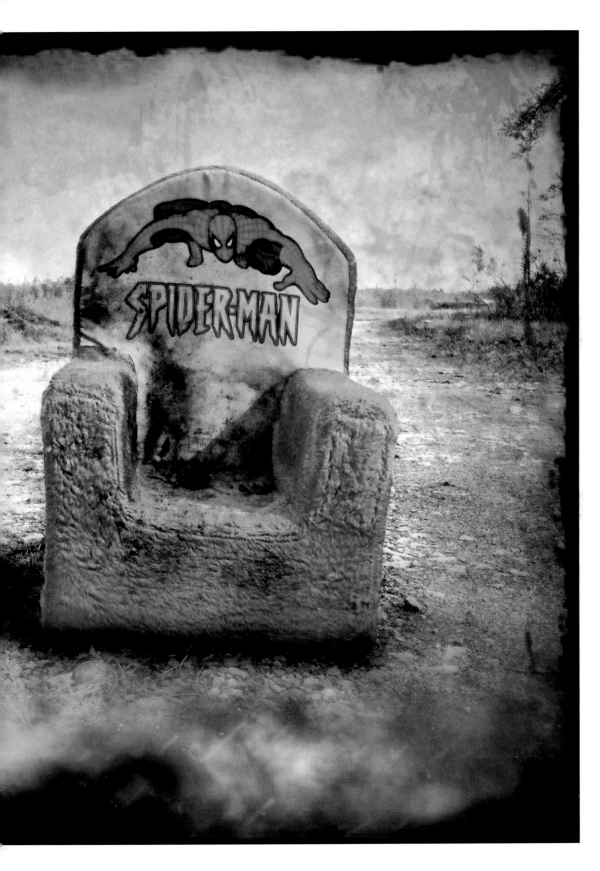

Try going crazy with layers over layers, type and texture, saturation, blurring, and sharpening and see what happens.

Grunge Mash-Up **FotoMuse, TiltShift, addLib, DXP**

Rearview Mirror

STEP 1 ProHDR (CHAPTER 8)
Merge two slightly out-of-register images together.

STEP 2 PictureShow (CHAPTER 11)
Add blue saturation and mirror the image.

STEP 3 PicGrunger
Add scratches.

Global Warming

STEP 1 Photoshop Express
(CHAPTER 2) Brighten and sharpen.

STEP 2 TiltShift (CHAPTER 4)
Blur and darken, desaturate around the globe.

STEP 3 FotoMuse
Add border and texture.

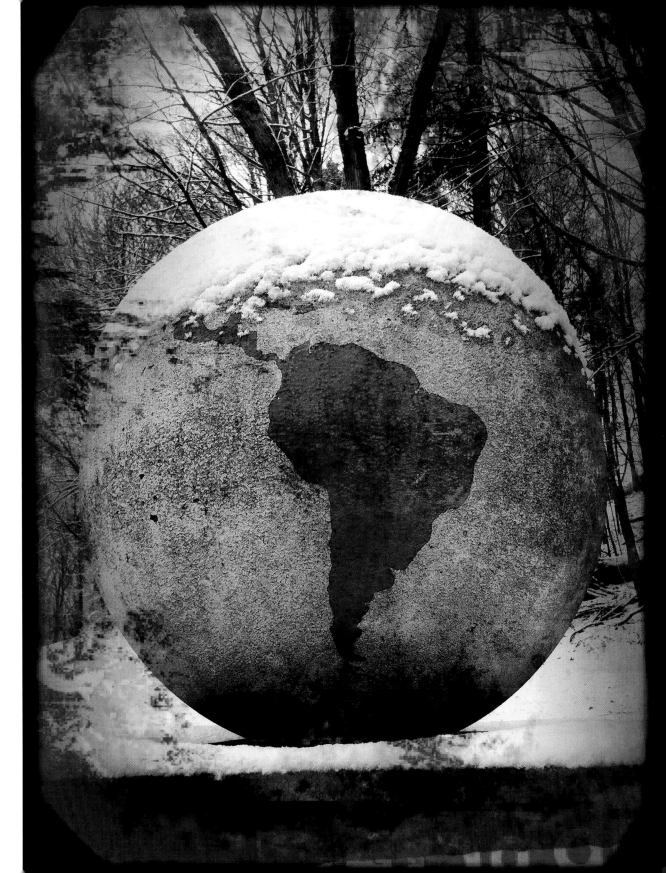

 PIC TAG *Scan this tag to download some cool custom textures and borders created by the author exclusively for this book.*

Needs a New Net

STEP 1 ProHDR (CHAPTER 8) Blend a bright and dark exposure together, then open shadows using brightness and contrast sliders and add saturation.

STEP 2 PhotoCopier Add custom grain and alter color tone using the Gauguin setting.

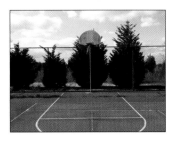

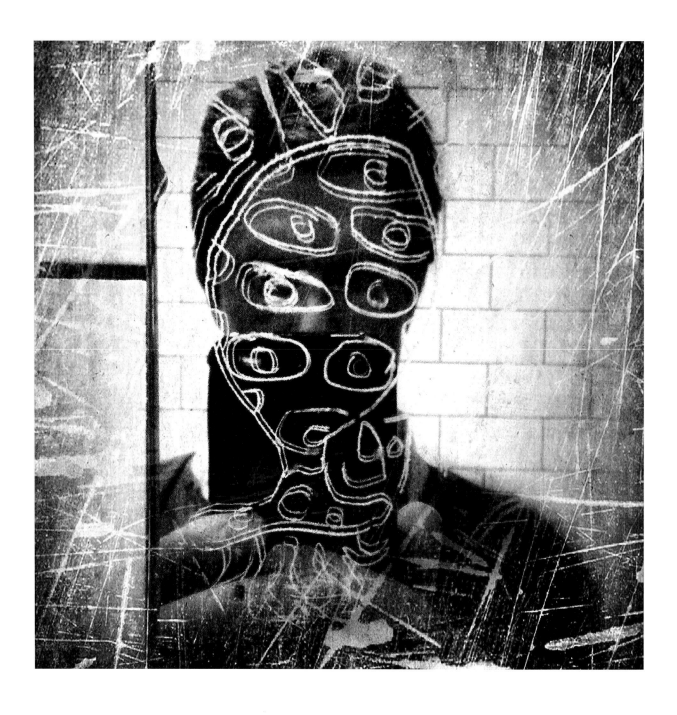

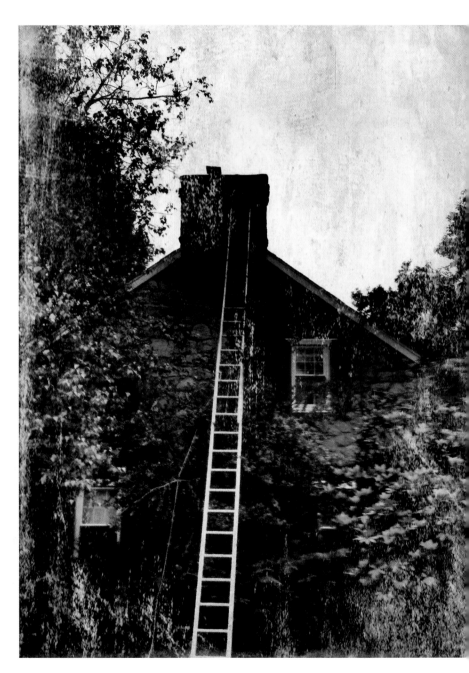

The Rose Factory

STEP 1 Photoshop Express (CHAPTER 2) Crop, brighten, convert to sepia, and sharpen.

STEP 2 PicGrunger Apply scratches and sepia texture.

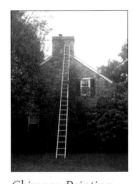

Chimney Pointing

STEP 1 ProHDR (CHAPTER 8) Blend a dark and light exposure.

STEP 2 FilmLab (CHAPTER 6) Change color tone, brighten, and sharpen.

STEP 3 PicGrunger Add scratches and sepia texture to edges and sky.

Chapter 4 Blurs and Vignettes

Scan the tags next to the app icons and see a short video from the author explaining each app's key concepts. In addition, you will have access to the iTunes download link and developer's Web site. The tag urls are also included in the Links Glossary on page 174.

In this chapter we will look at creative ways to make images less clear. That may sound counterintuitive, but blurring an image can make it more effective. Because mobile photos start out being a bit soft, it is easy to make a blur effect seem natural. The effect also gives the shot a dreamy quality, which allows for a more symbolic interpretation.

TiltShift is an app I turn to often. It gives me control of the depth of field and bokeh of an image. I tend to use the lens blur type more than the Gauss because you can control the highlight blooming and aperture shape that way. Also, it is best to experiment with all the slider controls. Try to see how far you can take the picture.

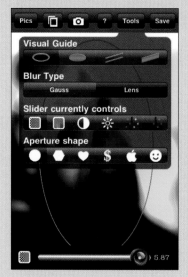

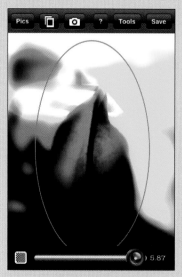

A dream app You can transform a scene into a miniature world. This application simulates a tilt-shift lens that tricks your mind into viewing a photo as a miniature.

Focus control With linear or circular guides in the image you can interactively adjust the amount and area of blur along with saturation, contrast, or brightness.

Create a nice bokeh With the lens blur filter option you get additional control. Blooming strength and threshold are adjustable, which allows for extreme effects.

 BlurFX allows me to control picture focus with a touch of my finger. So unlike with TiltShift I can blur areas selectively rather than in just a circular way. It also has a median blur type setting that TiltShift does not have. This setting is great for flattening an image down to simplified shapes that are blurred but have hard edges at the same time.

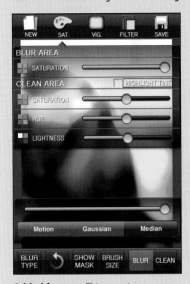 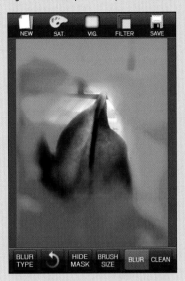 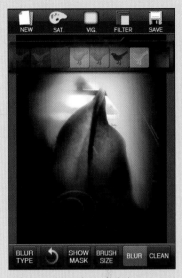

Added features This app gives some different options from TiltShift. You can independently control saturation, lightness, and hue in clean and blur areas.

See your mask You can use your finger to smudge in where you want the blur to occur and also see the mask by toggling it on and off.

Other settings Also included are a motion and median blur type, various color filters, and control of vignetting and framing.

 CameraKit brings an analog film look to your digital iPhone images. Although this app is a little slow in processing, for me the results are worth it. The soft focus gives the image a glow rather than a blur feel, and the push processing truly does feel like the film version. You can even add your signature.

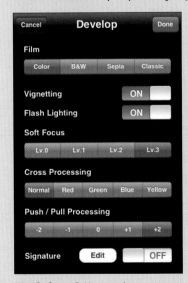 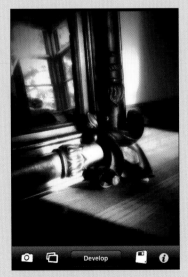 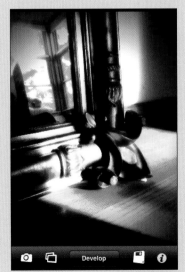

Worth the wait You can choose your type of film and add vignetting and flash along with developing your image in various traditional darkroom processes.

Sepia, my favorite You can develop with four film types and add three levels of soft focus. Flash and vignetting settings help create convincing filmlike effects.

Push and pull Just like in a traditional darkroom, you can experiment with cross-processing and darkening or lightening the image with push and pull settings.

TIP TAG

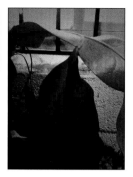

Night-Blooming Cereus / Process

THE MOMENT The simplest of images from your everyday life can have wondrous energy after a little blurring. This shot was taken in my basement as I was waiting for my laundry to dry. It is of an ugly plant that sits under a small window next to the dryer. **THE PROCESSING** With the right composition and balance of leaves and vines along with soft window light and a little bit of color saturation and edge blurring, this tiered plant has new life. I am surprised by how far you can push an image in TiltShift. The colors and edges can really get interesting with extreme slider combinations. **SCAN THE TAG TO SEE THE PROCESS**

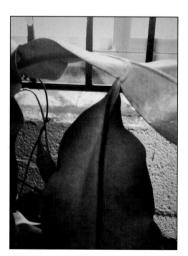

 Photoshop Express Brighten using exposure and saturation along with slight sharpening.

TiltShift Using the circular blur visual guide, I focused the main leaf. Using Gauss blur along with saturation and brightness, I pushed the edges of the image into oblivion.

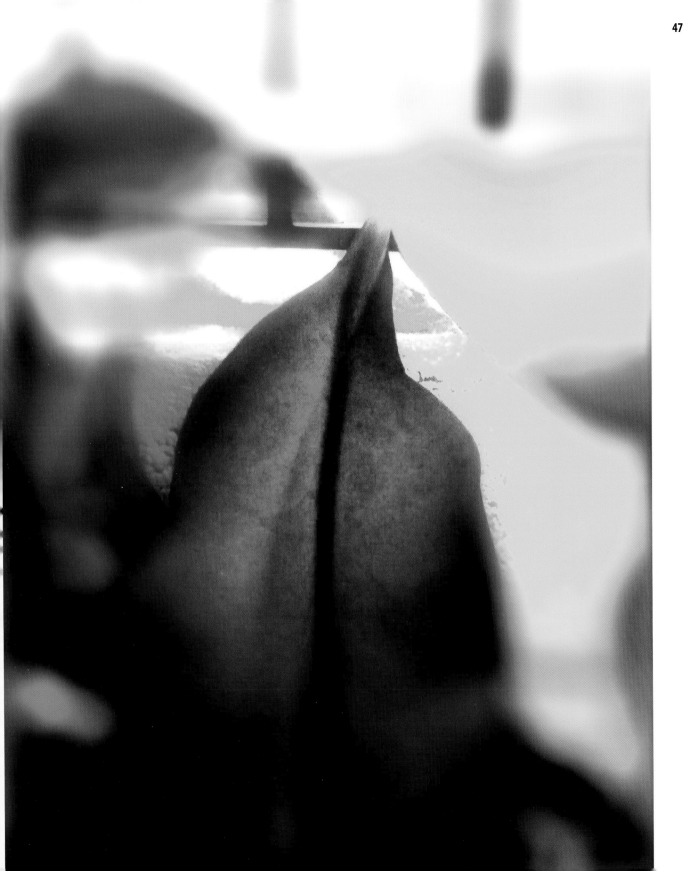

Crystal Antenna **TiltShift** Add blur and saturation around the center.

Art Weekend **TiltShift** Again, add blur and saturation around the center.

Look at everyday moments for picture possibilities. With the right framing and simple processing you can extract an interesting visual from any situation.

Duty Bound

STEP 1 Photoshop Express (CHAPTER 2)
Sharpen and brighten the base image.
STEP 2 TiltShift Blur and darken edges.

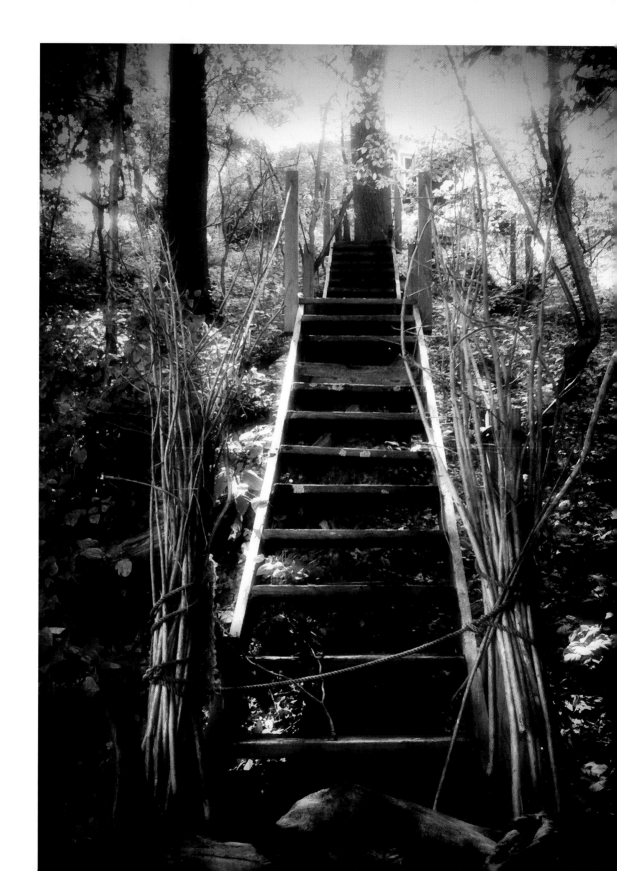

Forgotten Stairway / Process

THE MOMENT On a summer trip to the Chesapeake we wandered down a steep hill to a little secluded beach for some sunning and canoeing. When we got to the beach we noticed this dilapidated walkway rambling back up the hillside. The owner had it roped off and dressed up with tall bundles of branches on either side, which added to its intrigue. I had not brought my DSLR because of the sand and water. But of course I had my iPhone! **THE PROCESSING** After returning home from our trip I vignetted and converted the image to sepia tone to help accentuate the forgotten and foreboding qualities of the stairs. To add a sense of mystery, I achieved the hazy light by blurring the highlights.

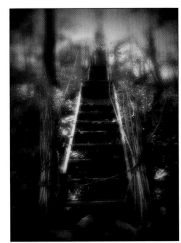

 CameraKit Develop the image to a sepia tone with a slight glow and push-process on level 2 to darken and add contrast.

TiltShift Accentuate the top edge of the stairs by blurring and darken slightly.

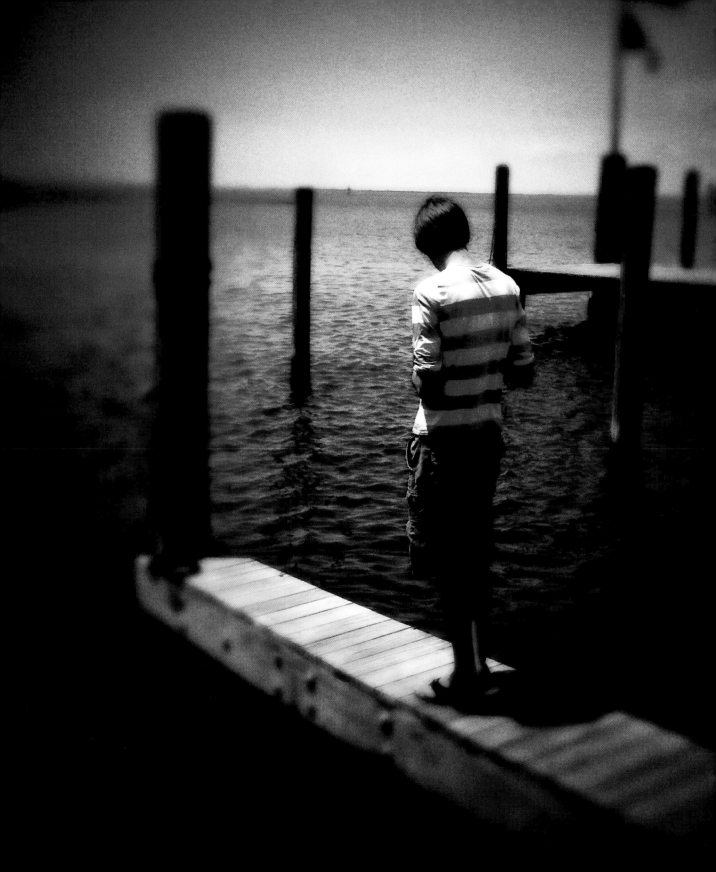

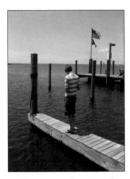

Danny on the Dock

STEP 1 CameraBag (CHAPTER 11)
Crop square and apply the
Helga effect.

STEP 2 FilmLab (CHAPTER 6) Use
a cross-processing setting to
alter color tones.

STEP 3 TiltShift Apply Gauss
blur to the edges and darken.

Too Many Bugs

STEP 1 TiltShift Lens blur
edges and add saturation.

STEP 2 FotoMuse (CHAPTER 3)
Apply grunge border.

*The emotional tensions in a
picture are increased when it is
vignetted. The viewer feels close
and involved with the subject.*

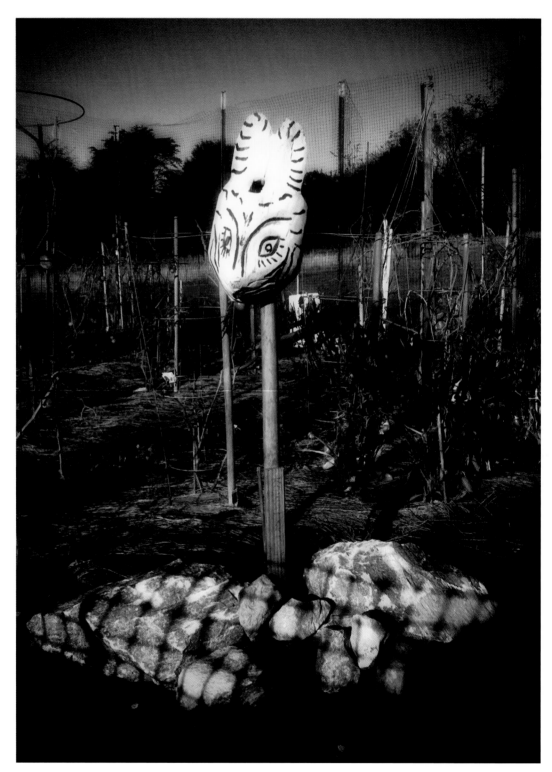

PIC TAG

Community Garden / Series

THE MOMENT For many seasons I have been visiting a community garden in my neighborhood. It is ripe with visual delights. In the spring there are the graphic patterns of newly placed fences and rows of seeds. The summer buzzes with color and overgrown green organic curls. And the fall garden, when I enjoy it most, has muted colors, fading newspaper ground cover, and the forgotten bits of gardeners' toils. **THE PROCESSING** To focus on the graphic nature of the garden and not be distracted by all the colors I turned to CameraKit, as it can render an elegant soft sepia image. **SCAN THE TAG TO SEE MORE IMAGES FROM THIS GARDEN**

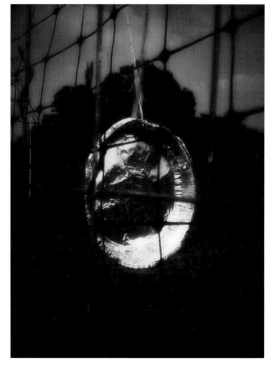

ALL IMAGES STEP 1 Iris Studio (CHAPTER 2) Open shadow tones and sharpen. **STEP 2 CameraKit** Develop with sepia, vignette, and flash settings turned on. Blur and push setting are set to level 2.

Chapter 5 Toon Looks

Scan the tags next to the app icons and see a short video from the author explaining each app's key concepts. In addition, you will have access to the iTunes download link and developer's Web site. The tag urls are also included in the Links Glossary on page 174.

Stripping away the detail and leaving just line and color is a nice way of adding interest to an uninteresting photo. The viewer is responding to a distilled essence of the image. It can help clarify your idea or even give it ambiguity. Either way, the result is injected with a bit of humor or wit by the cartoon effect.

 ToonPaint takes a photo and converts it into a line version. It also allows you to paint solid colors under the black toon lines. I have been doing graphics on the computer for over 20 years and have worked with many line conversion tools, and this app creates the most pleasing effect I have seen and allows lots of variations.

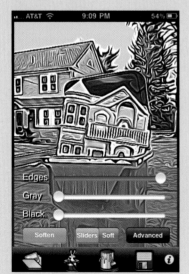

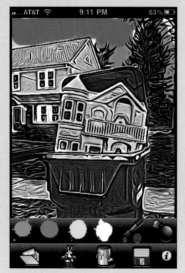

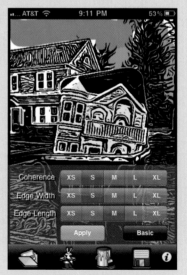

Magic sketch State-of-the-art image algorithms process your image to create a customized sketch. You control the amount of line and gray and black tones.

Add color You can color in the toon lines by painting with your finger. You can access three color pickers by double-tapping on the palette colors.

Thick to thin By touching the advanced button you can create a wide range of line interpretations, including very fine lines and fat, marker-like strokes.

 Percolator transforms images into an unexpected array of circles. This app caught me by surprise. At first I thought it was a bit silly, but it does such a great interpretation of the image structure and color that with the right photo it is worth using. It also has many image refinement options worth trying.

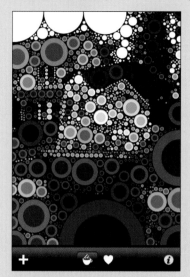

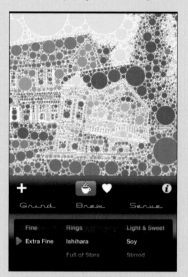

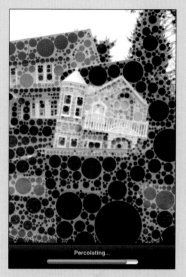

A graphic interpretation Try using images that are bold and graphic to start with or crop in close on an image to pick up more detail.

Grind it and mix it up With four grind detail settings, six pattern styles, and four mixing settings you can get many different looks.

Usage ideas Use Percolator to mix new color palettes for your designs. Add a dash of style to stale, old typography. Make patterns for Web site designs or illustrations.

 ArtistaHaiku transforms an image into dabs of paint and line. I almost put this app in Chapter 7, Painting Looks, but its simplified image of line and tone pushed toward the toon style. When I first used this program on an image I was stunned by the beautiful organic abstraction it created. (The controls are a little hard to understand.)

Add spontaneity The app incorporates traditional and digital techniques and vintage papers to create a unique painting filled with movement and meaning.

All set with presets As a starting point there are about 16 presets. They take a little while to process, but trying them all will show you what's possible.

Save presets Once you find a preset you like, refine the settings to fill the image more with paint or change the line strength, or try one of the 48 paper backgrounds.

TIP TAG

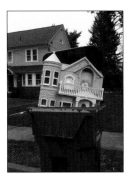

Barbie's Dream House / Process

THE MOMENT Driving past a house in my neighborhood I stumbled upon this image. Again, I was not out to take photos, but since I always have my iPhone, pictures can just happen organically. I never even got out of my car. I drove slowly past the trash can to get just the right amount of overlap with the house in the background and snapped the image. **THE PROCESSING** Since the lighting was very flat and the image was mostly about architectural line and form, converting it to toon made sense. This is also a rare case when I experimented with using a desktop computer to further enhance the effects. By tracing the ToonPaint line work in Adobe Illustrator you can get a pretty close match to the original, but the beauty is that it is now in vector format. This allows you to scale it up to any size without losing quality. Then I composited three layers in Adobe Photoshop with a scaled-up original and blurred version. **SCAN THE TAG TO SEE THE PROCESS**

 ToonPaint Render two line versions of the image with some nice grays and a few blacks but no color. Then trace both in Adobe Illustrator to get a vector version.

 BlurFX Blur with the median setting at 35 percent and add maximum saturation. Bring this version and the original version into Photoshop and scale to 200 percent.

 Photoshop Put the blurred version on the bottom layer and the original next, set to 75 percent hard light blend. Place one vector version on multiply 35 percent and the next on hard light at 100 percent.

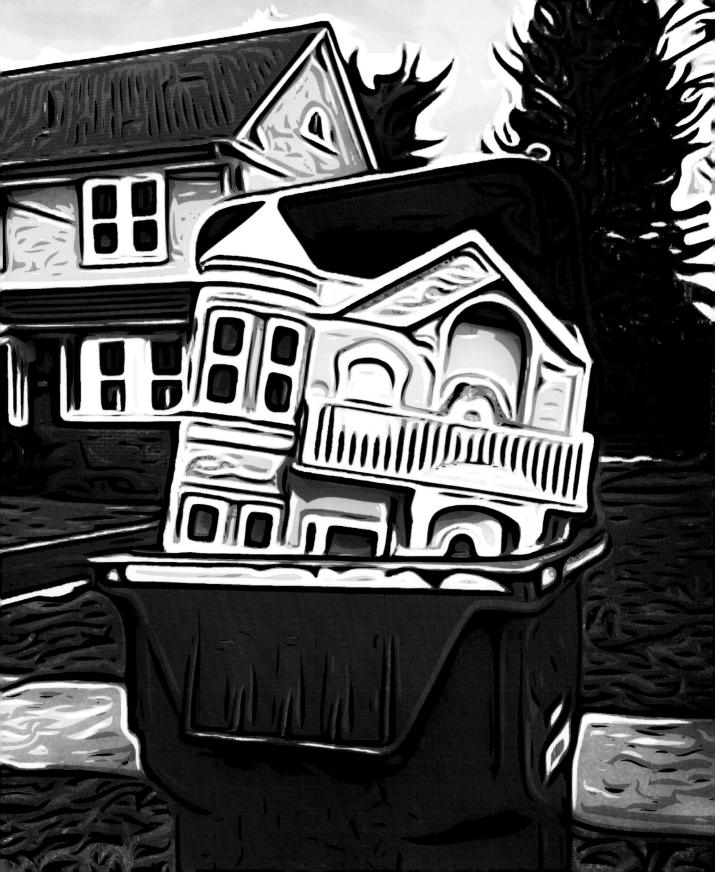

Here is an assortment of portraits done with ToonPaint as the base app. Try it on simple objects like a piece of fruit—they take on a new life.

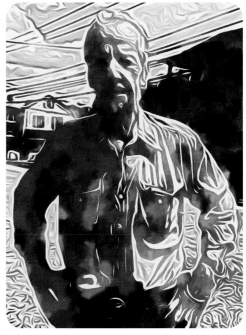

The Master Retoucher

The Daughter

The New York Art Director

The Distant Cousin

The Eye Surgeon

The Son's Girlfriend

The Son

Bathing Beauty / Variation

THE MOMENT As I was walking through this sea of pool people the scene here appeared out of the corner of my eye and I blindly snapped this frame. Although it is an unlikely bathing beauty shot, two things drew me to it. One is how the strong sun brought out the graphic lines of the shot; the other is the lady's gestures. If her left knee had not been bent up this shot probably would not be in this book. **THE PROCESSING** My objective was to extenuate the woman's gesture and the graphic composition. The contrasty black-and-white version was good, but I was missing the strong blue color, so I tried merging a freehand drawing over a very blurred color version (below). But I felt I got the best of both worlds with the version to the right.

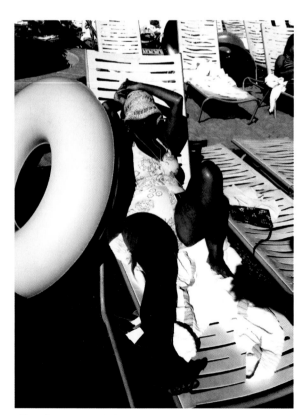

FilmLab (CHAPTER 6) Use Slit Toning-Moon Mist preset and sharpen.

STEP 1 BlurFX (CHAPTER 4) Median-blur 50 percent with high saturation; add some random transparent strokes of nonblurred image back on top.
STEP 2 SketchClub (CHAPTER 12) Trace photo with loose freehand white line.
STEP 3 DXP (CHAPTER 2) Merge steps 1 and 2 with screen mode.

ArtistaHaiku Customize settings to best capture gesture lines in a picture.

Globe Rediscovered

STEP 1 Photoshop Express
(CHAPTER 2) Straighten and crop globe image.

STEP 2 Percolator Use the fine, rings, and black settings.

Hulk Hand

STEP 1 Percolator Use the fine, rings, and black settings.

STEP 2 ToonPaint Convert hand to toon lines.

STEP 3 Filterstorm (CHAPTER 12) Blend the hand in the original with step 1 through a mask. Crop image square.

STEP 4 Bad Camera (CHAPTER 12) Randomly select vintage overlay and then convert to sepia tone.

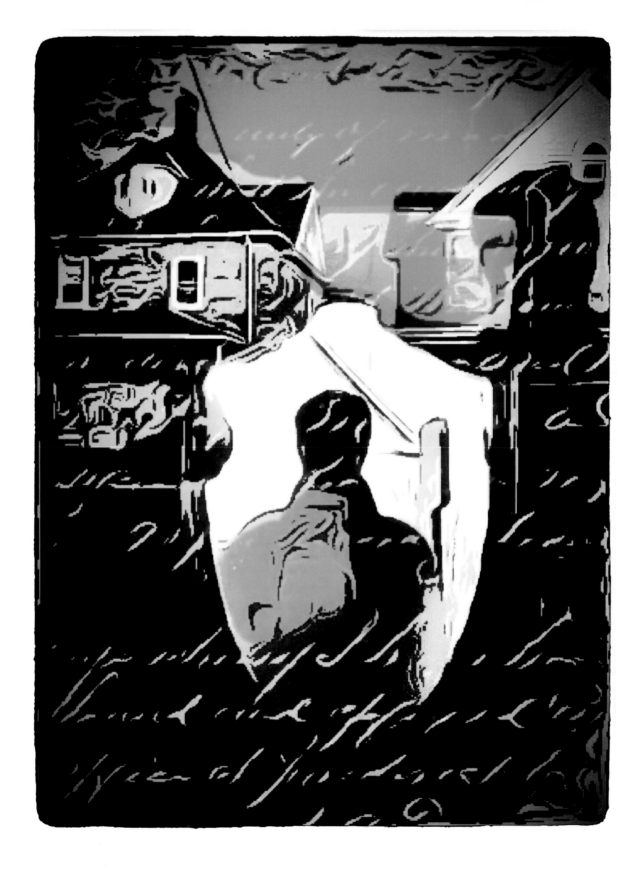

Silk Orange Tree

STEP 1 ToonPaint Export black line and gray conversion.

STEP 2 BlurFX (CHAPTER 4) Median-blur original image at about 65. Add saturation and stroke in some soft hints of the original image in the leaves and so on.

STEP 3 DXP (CHAPTER 2) Merge steps 1 and 2 with multiply blend mode.

STEP 4 LoMob (CHAPTER 11) Add 6 by 9 instant emulsion effect.

My Graphic Novel

STEP 1 FotoMuse (CHAPTER 3) Add grunge border and type layer.

STEP 2 ToonPaint Export black line and roughly painted line conversion.

STEP 3 LoMob (CHAPTER 11) Use postcard three setting.

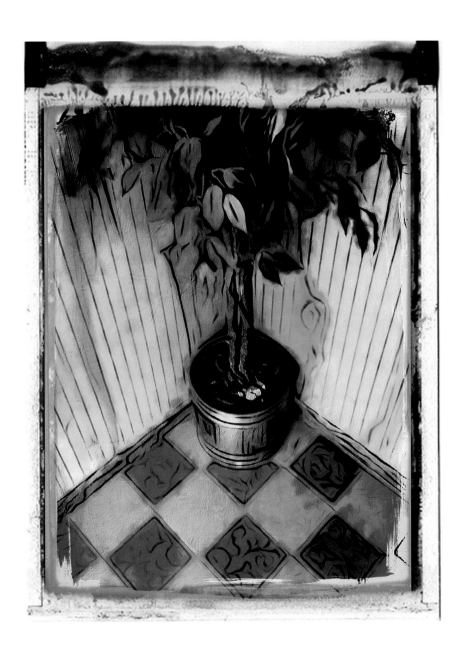

TIP TAG

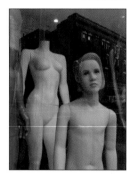

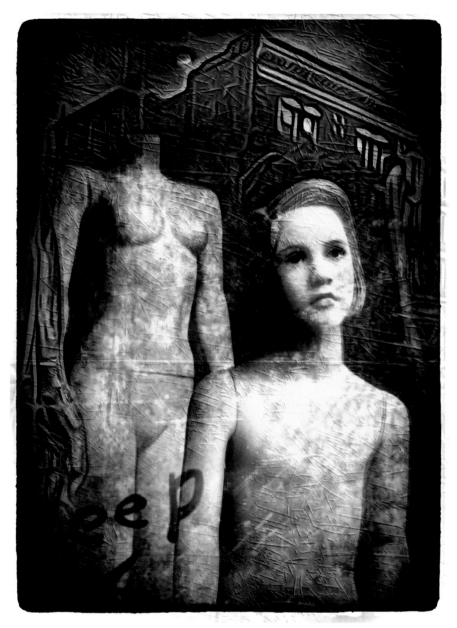

Window Dressing **STEP 1 ToonPaint** Create black and gray line work.

STEP 2 DXP (CHAPTER 2) Composite line work over blurred original image using multiply.

STEP 3 FotoMuse (CHAPTER 3) Apply grunge border and texture.

STEP 4 TouchUp Studio (CHAPTER 2) Brush back in original girls and emboss scratch texture.

STEP 5 LoMob (CHAPTER 11) Apply postcard 3 setting.

SCAN THE TAG TO SEE THE PROCESS

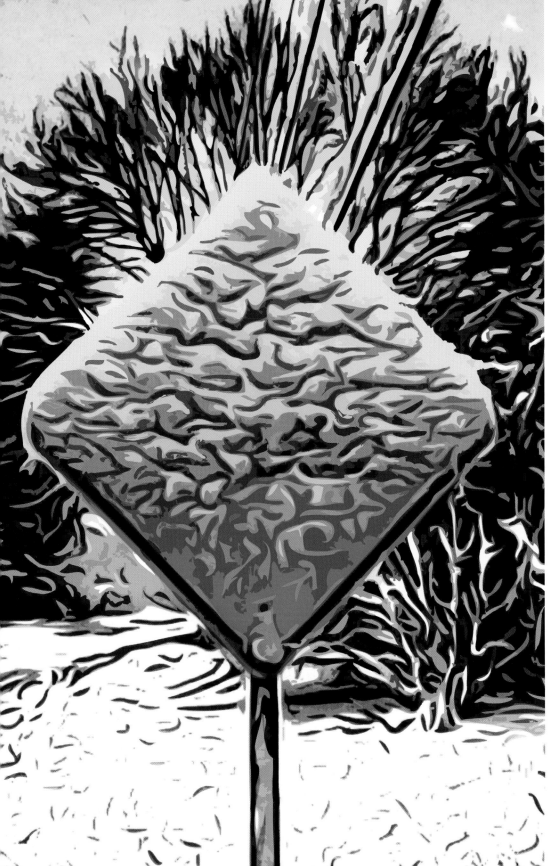

Snow Children

STEP 1 ToonPaint Create black line work with hard setting slider.

STEP 1 Photoshop Express (CHAPTER 2) Add exposure, contrast, saturation, and sharpness.

STEP 1 DXP (CHAPTER 2) Combine two images with colordodge layer mode.

Scan the tags next to the app icons and see a short video from the author explaining each app's key concepts. In addition, you will have access to the iTunes download link and developers Web site. The tag urls are also included in the Links Glossary on page 174.

Chapter 6 Film Looks

Do you still love the analog look of film, the creamy colors, the raw grain or perhaps even enchanting light leaks, and the sprocket markings? Well, there is an app for that. By adding a film look you can give an image instant credibility along with a touch of nostalgia and an overall warm feeling. If you merge a digital picture moment with a creamy filmlike veneer you get some interesting unexpected results with a slight smell of chemistry.

 PlasticBullet magically transforms images into glowy, ethereal impressions that look like they were taken out of an old photo album. I use a desktop variation of this app called Magic Bullet Looks in my video production work. This app really gives images a convincing film look. The only downside is that I end up saving too many variations.

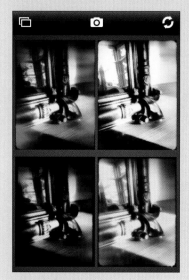 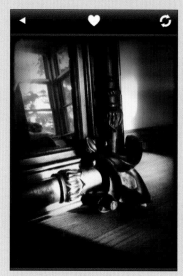 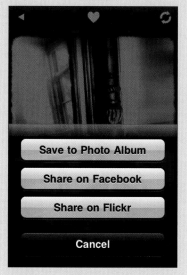

Random fun The app automatically generates random combinations of blur, tone, and color shifts along with light leaks, border effects, and grain.

Endless variations Start with the built-in camera or a shot from your Photo Library. Every time you touch the button a new random effect is shown.

Share Like one? Tap it to see it larger. Love it? Tap the heart to save. You can also share on Facebook or Flickr directly from PlasticBullet.

 FilmLab is a film simulation application that transforms iPhone into a film camera. I use this app to prepare an image or finish an image. Not only does it have endless film simulations that are nicely organized, tagged, and named, it also has a nice set of image improvement tools like sharpen and brighten.

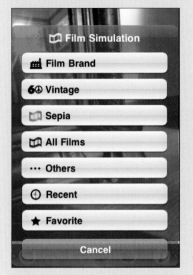

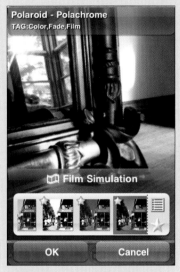

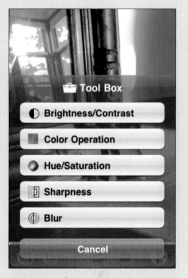

Almost too many possibilities This is a nice app to prep or finish an image. It really can change the attitude of a shot.

Favorites Scroll left to right through 79 styles including Calotype and Daguerreotype along with lots of color film types and save your favorites.

More control Also adjust the brightness and contrast, do color operations, and control hue and saturation, color balance, sharpness, and blur.

 Hipstamatic is one of the hottest photo apps available. It works as a substitute camera, one which allows you to change lenses, film, and flash. The results are unexpected and feel like old snapshots. I do not use this app too often. But when I do I am addicted again. After a while though, I find it a little too slow and canned looking.

Instant art Bring back the look, feel, unpredictable beauty, and fun of plastic toy cameras of the past. Keep the quirks of shooting old school with the ease and instant gratification of digital.

Accidentally on purpose Characterized by vignettes, blurring, oversaturation, and discolored images, Hipstaprints have a casual and seemingly accidental snapshot feel.

Buy more options Additional lenses, films, and flashes are bundled within the app as Hipstapaks and start at 99 cents. Each Hipstapak includes multiple items.

TIP TAG

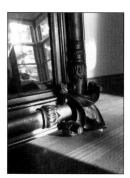

Afternoon Mirror / Process

THE MOMENT The time of day and the quality of light can conjure up a fleeting picture moment. In addition, mixing light types, indoor and skylight, can give you that great warm yellow and cool blue contrast as in this picture. **THE PROCESSING** I tried to enhance the color contrast of yellow and blue with FilmLab and the soft light qualities with TiltShift. The vignetting helps focus attention on the sharp, ornate features of the mirror.

SCAN THE TAG TO SEE THE PROCESS

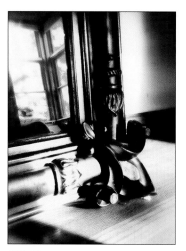

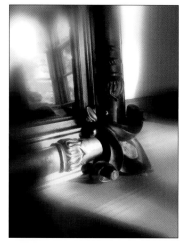

 FilmLab The film simulation style I used was Cross processing, Blue lagoon. I then added saturation and sharpness.

TiltShift Set lens blur and saturation near maximum and contrast and brightness at half.

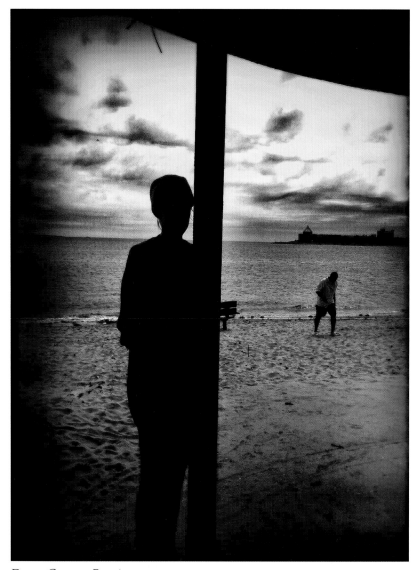

Dana Goes to Russia **PlasticBullet** Random selection mode.

 See our broadcast video work, including examples where Magic Bullet was used.

TIP TAG

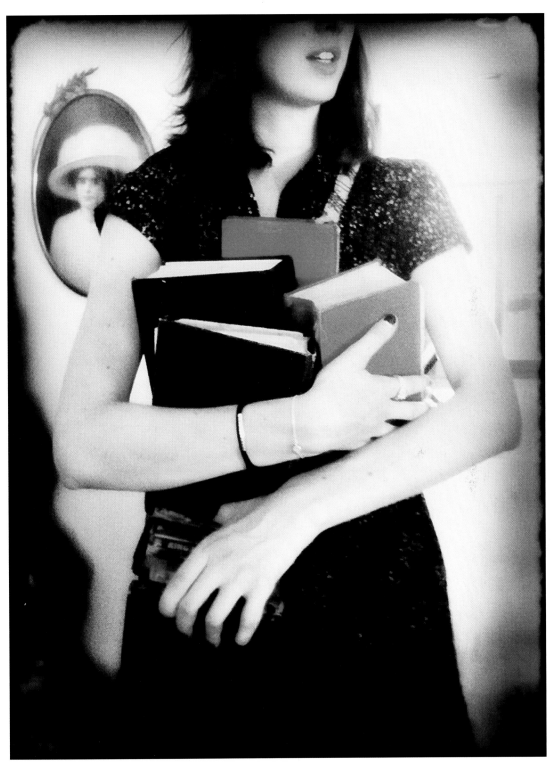

Dana Goes to School **PlasticBullet** Random selection mode.

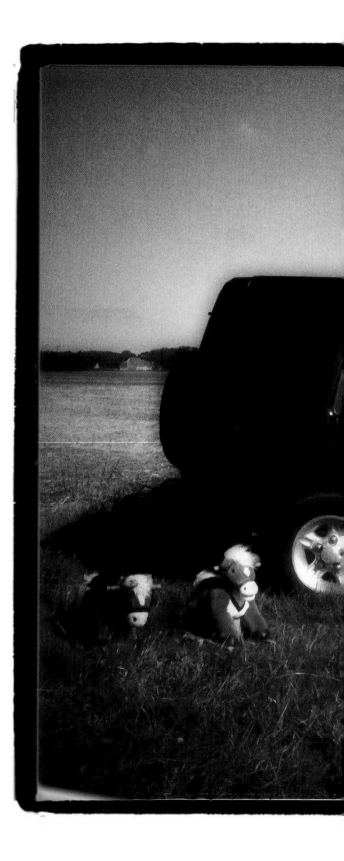

Yard Sale Horse

STEP 1 ProHDR (CHAPTER 8) Merge a dark and light exposure.

STEP 2 Iris Studio (CHAPTER 2) Open shadow, and sharpen.

STEP 3 CameraKit (CHAPTER 4) Use sepia setting with blur and push processing at level 2 with flash on.

STEP 4 PhotoFX (CHAPTER 2) Add custom film grain.

STEP 5 PictureShow (CHAPTER 11) Add border and light leak.

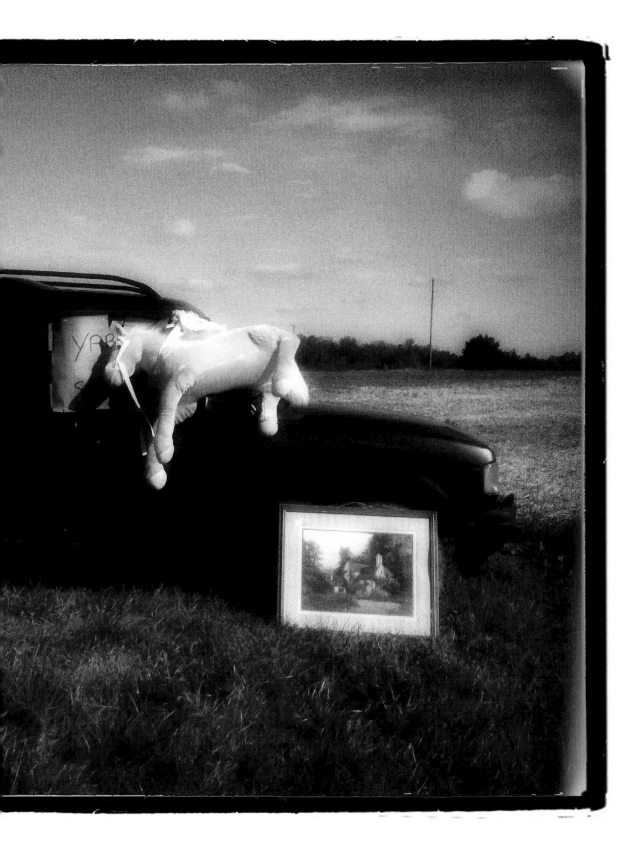

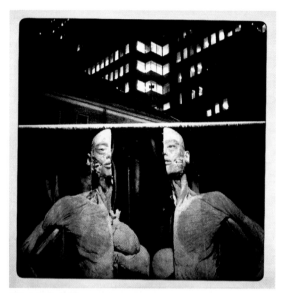

Divided Office **Hipstamatic** John S lens and Blanko film.

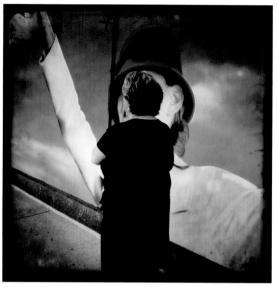

Snow Brush **Hipstamatic** Helga lens, Float film, and flash.

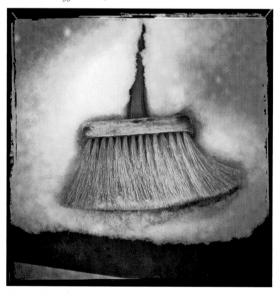

Snow Brush **Hipstamatic** Robot lens and BlacKeys film.

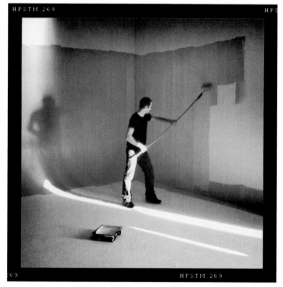

Set Change **Hipstamatic** Kaimal lens and Pistil film.

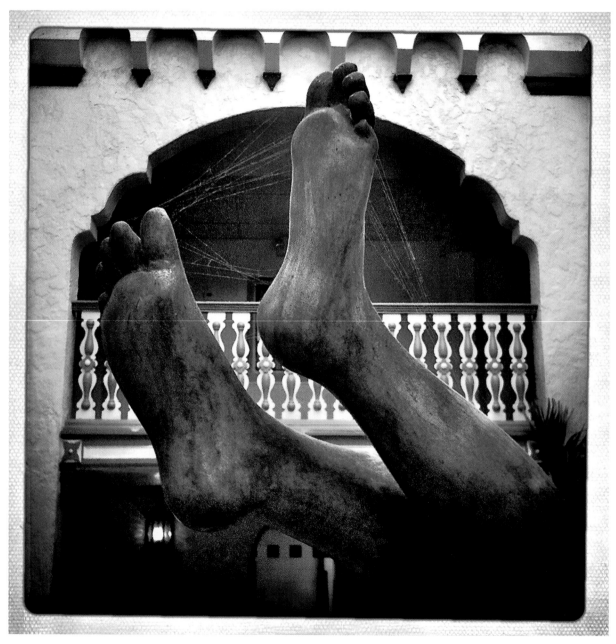

Forgotten Feet **STEP 1 Hipstamatic** John S lens and Ina's 1969 film. **STEP 2** Iris Studio **(CHAPTER 2)** Open shadows convert to sepia tone.

The Chosen One **STEP 1** **Hipstamatic** John S lens and Ina's 1969 film. **STEP 2** **Iris Studio** (CHAPTER 2) Lighten and add saturation.

Exercise Waits

STEP 1 PlasticBullet
Use the random setting.
STEP 4 PhotoFX (CHAPTER 2)
Add custom film grain.

Coneheads Table

FilmLab Use cross-processing style called Kodak Royal Gold 400. Plus add sharpness and strengthen yellow.

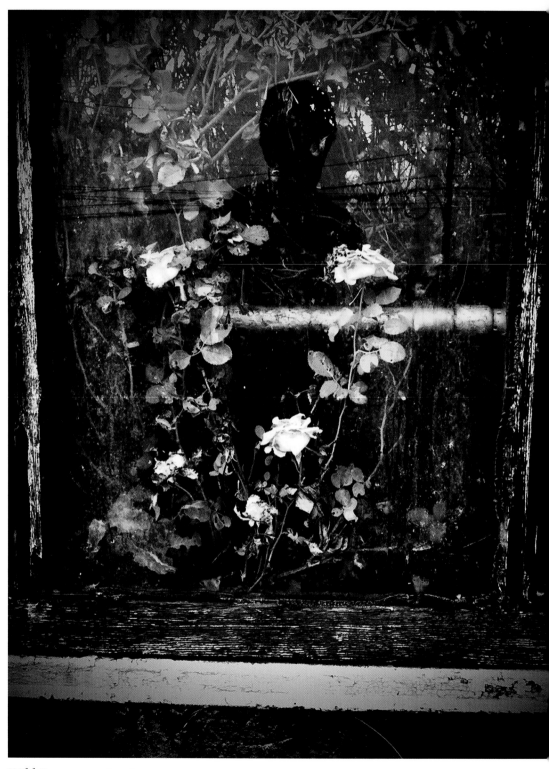

Wild Roses **STEP 1 FilmLab** Use split toning, sepia, bison hide color style. **STEP 2 CameraBag** (CHAPTER 11) Use Helga style, no crop.

Rose Factory / Series

THE MOMENT On my way to weekend shopping I sometimes pass this abandoned rose hothouse. The owner told me it became too expensive to heat and cool an all-glass building. But even after many years of being unattended the roses still bloom. **THE PROCESSING** I have tried many techniques on my pictures from this location. The black-and-white film look to the left is one of my favorites because it does not depend on the rose color.

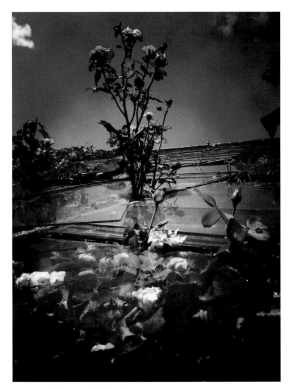

Wild Roses **PictureShow** (CHAPTER 11) Lomography color setting with smoke noise style.

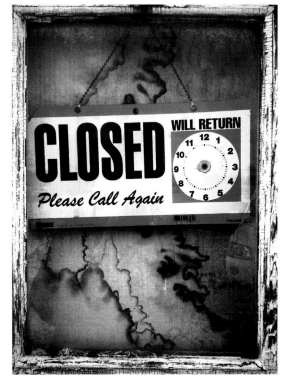

Will Not Return **PictureShow** (CHAPTER 11) Lomography color setting with smoke noise style.

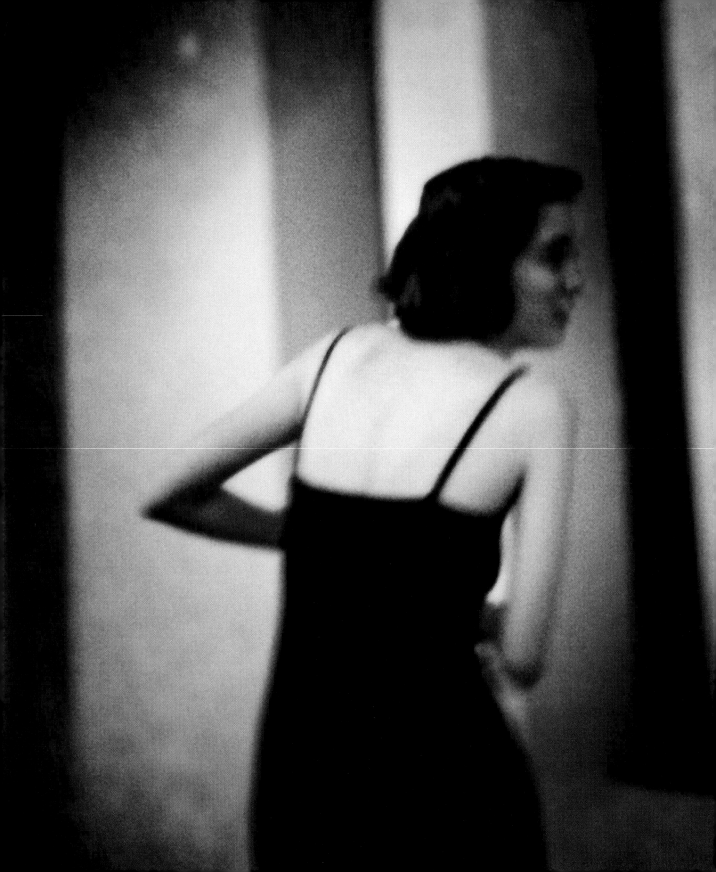

Dana in No Exit **Hipstamatic** John S lens and Ina's 1969 film.

Download a reference file showing almost every Hipstamatic film and lens combination.

Chapter 7 Painting Looks

Scan the tags next to the app icons and see a short video from the author explaining each app's key concepts. In addition, you will have access to the iTunes download link and developer's Web site. The tag urls are also included in the Links Glossary on page 174.

To some purists, converting a photo into what looks like a painting is considered cheating or tacky. I prefer to think of the process as photo illustration. Taking the energy of a photo and minimizing its reality sometimes maximizes its symbolic or emotional qualities. The low-res qualities of mobile photos can give just enough detail to render an effective painted look. By blending and layering different app effects you can come up with a unique hybrid of an image that feels honest and less like cheating.

 Artist'sTouch allows you to selectively clone-paint an existing image. There is no other app I know like it. You start by importing a photo; the app then creates a ghosted line-drawing version. After choosing a brush type and size you paint back in the image color and detail. Change the size of the brush to get more detail in certain areas.

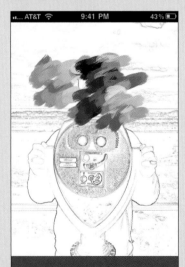

Fill in the details The secret is to work with broad strokes first for background elements, then change to a smaller brush with short strokes for the detailed areas.

Multimedia Select different paint modes like watercolor, oil, chalk, airbrush, or pencil to get different painting styles.

Paper choices You also have access to the paper texture and color. Choose textures like canvas, rough paper, or my favorite, cracked paint.

 ArtistaOil translates your image into an oil painting. Generally I do not like this kind of cheap trick on images, but this app really does generate a pleasing result. I like to start with an image that I have already manipulated in some way, either with a slight distortion, blur, or color change. This helps push it into a believable painting.

Step by step Just follow the buttons on the bottom. Start by choosing one of many presets, and check details along the way by zooming in.

Slide the paint around Once you have a preset you like, you can then tweak the sliders to get something unique and appropriate for your subject matter.

Finishing touch The last step is to choose the kind of painted edge you want, and there is a wide selection available. Then save your image and custom preset.

 SketchMee turns your photo into a vector line drawing. The results are really remarkable—there is no desktop app that can do this as well. The best part is you can e-mail a full vector version to yourself that is editable in Adobe Illustrator. I sometimes restroke the lines with one of the art brushes in Illustrator to give it a softer look.

Convincing results The image is redrawn in front of your eyes. The line work follows the contour lines of the original and gives it a convincing hand-drawn look.

Tweak your results Try various techniques like colored pencil or chalk. Change seven settings to affect the final output. I like the new combo setting best.

Unlimited size output Input images can be of any size. Tiny Web images are easily transformed into works of high-resolution sketch art. Zoom in to see the detail.

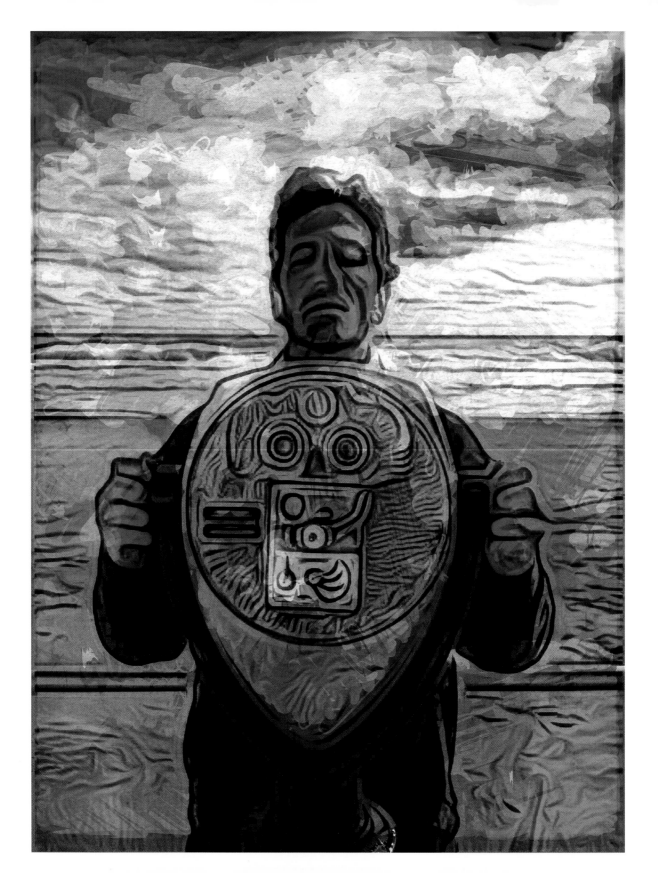

TIP TAG

Endless Summer / Process

THE MOMENT When my editor nixed my original cover image (seen on page 6), I needed to find new subject matter. I found this picture while obsessing about which surf break to paddle out in. The waves and sky were great and along with this quirky, nostalgic vacation viewer I had the makings of an interesting cover. I took many shots, but it wasn't until Paul closed his eyes that the picture came together.

THE PROCESSING I wanted the style of the processing to capture a whimsical, dreamy quality. Also, since this was going to be the cover I wanted to use multiple apps. Ideas from the chapters "Straightforward," "Blurs and Vignettes," "Toon Looks," "Film Looks," "High Dynamic Range," and this chapter are all used. **SCAN THE TAG TO SEE THE PROCESS**

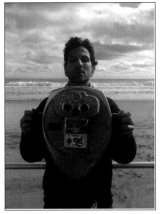

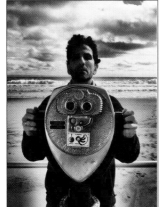

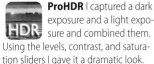

ProHDR I captured a dark exposure and a light exposure and combined them. Using the levels, contrast, and saturation sliders I gave it a dramatic look.

FilmLab To bring out the nostalgic warm qualities of the image, I chose the setting called Pharlap. With the other tools I tweaked the color and sharpened the image.

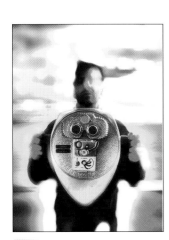

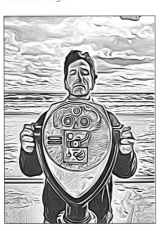

TiltShift I then used TiltShift to dramatically blur the image with the lens setting. Extreme saturation, contrast, and aperture highlights helped make the image even wilder.

ToonPaint I processed the original photo into a toon variation with the soft slider setting. A balanced amount of gray and black edges were generated.

SketchMee I used the color chalk setting. Then I opened the exported PDF in Adobe Illustrator and retraced the line work with the artistic charcoal pencil.

Photoshop I layered the four resulting files into Photoshop: HDR image on the bottom, Illustrator strokes next, set to 90 percent luminosity, TiltShift image next at 40 percent color, and ToonPaint on top, set to 45 percent linear burn.

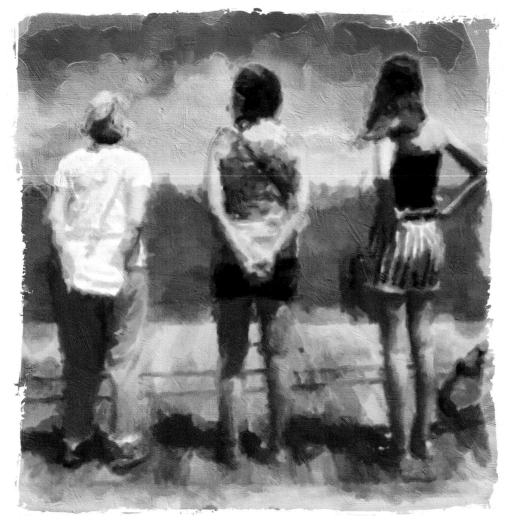

Three Generations

STEP 1 Photoshop Express
(CHAPTER 2) Import high-resolution photo from a DSLR and brighten, sharpen, and crop.

STEP 2 Artist'sTouch Clone-paint with broad brush.

STEP 3 DXP (CHAPTER 2) Merge the image from step 1 with the image from step 2 using the halfblend setting.

STEP 4 ArtistaOil Render with the straight brush preset.

Summer's Ending

STEP 1 Perfectly Clear
(CHAPTER 2) Auto brighten and sharpen original image.

STEP 2 ArtistaOil Render with the curved brush preset and soft edge.

STEP 3 PhotoCopier (CHAPTER 3) Render with a customized Monet setting.

STEP 4 Photoshop (DESKTOP) Merge the PhotoCopier version over the top of the ArtistaOil version using the lighter color blend mode.

STEP 5 PictureShow (CHAPTER 11) Add border and light leak.

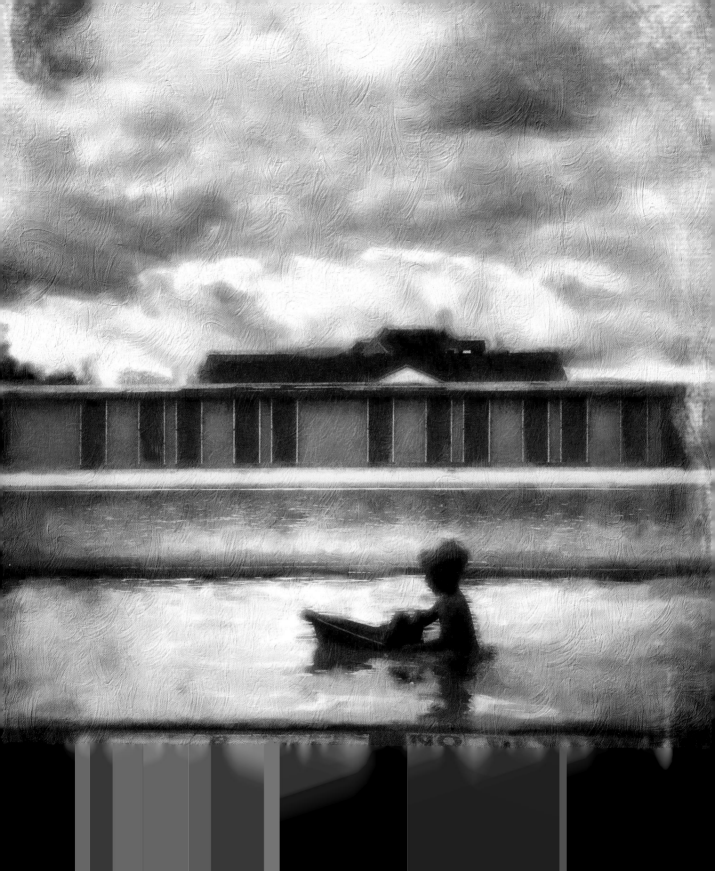

TIP TAG

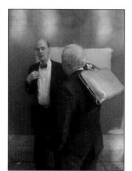

At the Parking Garage / Process

THE MOMENT This image is a great example of what I call "hearing the phototone." As I was going to my car I passed these fine gentlemen conversing, and the combination of lighting, design, and gesture all came together. This is when I hear a tone in my mind's ear that forces me back to quietly snap the picture. If you open yourself up to such moments, their design rhythm and emotional balance will alert you to open your phone. I can't really tell you how to hear the phototone; you just always need to be listening. **THE PROCESSING** While sitting in traffic on my way home I developed the first iteration of the image. It is a basic process I use often, layer-blending a very abstracted painted version of the image with a sharpened lightened version. **SCAN THE TAG TO SEE THE PROCESS**

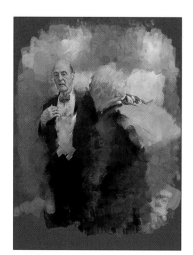

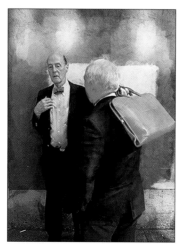

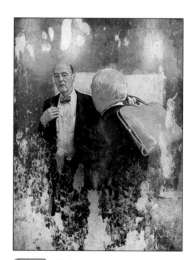

 Artist'sTouch Quickly thumb-brush in some short, fat color-cloned strokes. Change the brush size and brush higher detail into the face and hand.

 Iris Studio Import the original photo and open up shadow areas, brighten highlights, and sharpen and saturate. Bring in the painted version over the top and use the overlay blend mode.

 PicGrunger I experimented with various effects and decided on sponged at around 80 percent with border turned on.

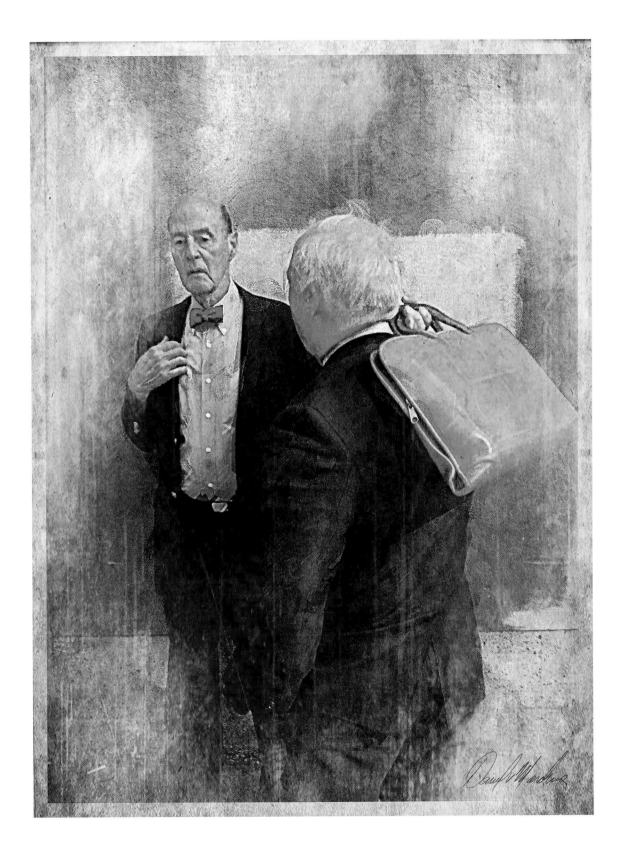

Walking to Hair

STEP 1 Artist'sTouch Clone-paint with broad strokes around the man. Change his brush size and paint with more detail on his face and hand.

STEP 2 TiltShift (CHAPTER 4) Use the original image and Gauss-blur, saturate, and brighten all but the man's face.

STEP 3 DXP (CHAPTER 2) Combine the painted version with the blurred version using hardlight mode through a black-and-white brushed mask.

TIP TAG *Scan this tag to see some apps that allow you to take pictures without being obvious.*

Fashion Shoot / Series

THE MOMENT As an art director at a photo shoot I snapped these images from the right of the main camera. The shot shows the assistant securing the wall behind the model. **THE PROCESSING** I wanted to abstract and simplify the images to the point of making them more like a story illustration. Then when I put the three views together like this, out of context, they begin to tell a tale of an unfulfilled romance—or maybe a creepy stalker.

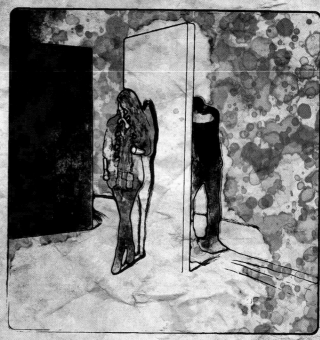

BOTH IMAGES STEP 1 ArtistaHaiku (CHAPTER 5) Open shadow tones and sharpen.

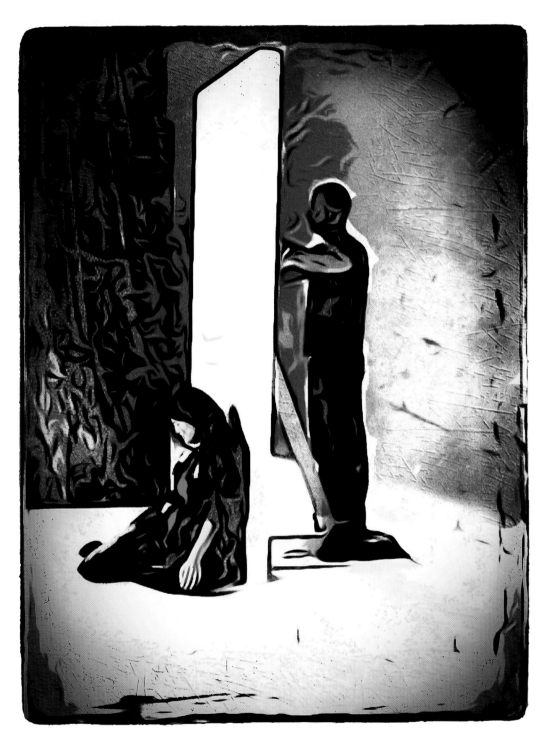

STEP 1 Iris Studio (CHAPTER 2) Open shadow tones and sharpen. **STEP 2 CameraKit** (CHAPTER 4) Develop with sepia, vignette, and flash settings turned on. Blur and push setting set to level 2.

Full-Body Portraits / Process

THE MOMENT A good full-body portrait results from how the light hits a subject or the surroundings or the gesture of the person. A really good portrait is when these elements all come together. **THE PROCESSING** These two examples were done by using the unique qualities of an app called SketchMee combined with Photoshop. This app takes input from a photo and can redraw it in many different styles. The advantage is that you can export it via e-mail as a PDF in vector format. You can then scale it indefinitely without losing sharpness. When you bring in a softened or painted version of the original image and layer it with the vector using a blending mode, the results can be very illustrative in feeling. **SCAN THE TAG TO SEE THE PROCESS**

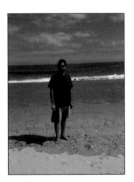

TIP TAG

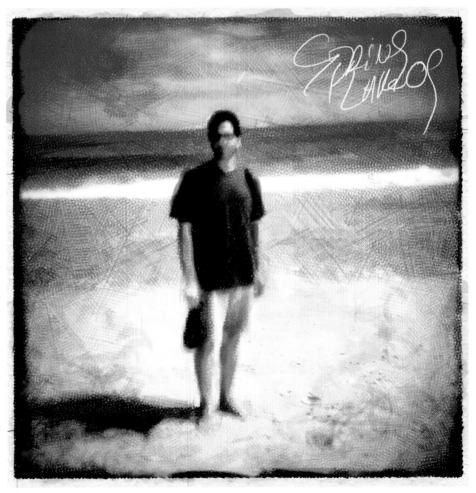

Chapter 8 High Dynamic Range

Scan the tags next to the app icons and see a short video from the author explaining each app's key concepts. In addition, you will have access to the iTunes download link and developer's Web site. The tag urls are also included in the Links Glossary on page 174.

One of the limitations of a small sensor in a mobile camera is the lack of dynamic range. But what if you could blend the highlights of the dark image with the shadow areas of the light image to capture a much wider dynamic range?

Well, you can, with a technique called high dynamic range, or HDR. This technique has been around for a while, but with some recent software tools it has really taken off on the DSLR side of photography. Now the mobile market has a few good affordable solutions as well. In addition to the two HDR apps profiled here, Apple has now built the technique into its latest iPhone. In working with these apps, I have really been impressed with the results. You can take dark and light shots automatically with the app determining the different exposures, or you can do it manually. To do it manually you touch the screen in a highlight area, snap the dark picture, and then touch a dark area to snap the light image. Since the two frames need to match perspectives closely, I find the auto works a little better because you can concentrate on holding the camera steady and not fumble around with touching the screen.

The process works best on contrasty scenes shot with the camera on a tripod or propped up on a table. But these apps can also be used creatively to combine not-so-exact frames together. The results can be very interesting.

 ProHDR automatically takes a dark and light shot, then aligns the images and blends them, delivering a really impressive image. But more than that, it then allows you to tweak the parameters of the resulting image to make it even better. I use it on landscape scenes, as it keeps the sky from blowing out.

Choose a mode Auto mode analyzes the scene, then takes a dark and light image for you. Manual mode prompts you to take each image, giving you more control.

Best of both worlds Image alignment algorithms align images quickly but not always perfectly. It's essential to hold the camera as steady as possible.

Adding pop Fine-tuning is a bonus in this app. By working with the brightness, contrast, and saturation, you can make a big difference in the final image.

 TrueHDR lets you merge two exposures for extended dynamic range. Although I tend to like ProHDR a little better because you can tweak the picture afterward, this app is worth a try. It does have less haloing in tonal transition areas and has an enhanced mode I like for some images, as it gives them a super-real feeling.

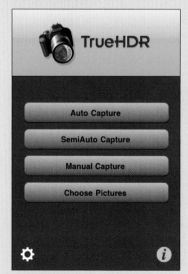

An extra mode In addition to auto capture and manual capture, TrueHDR has semi-auto capture, which allows you to choose the shadow and highlight areas before you start the capture.

Use your library You can always just take pictures from your library so you don't have to open these apps to take shots. Just use a dark and light version and merge them later.

Enhanced mode This app has a natural and an enhanced mode. I like the enhanced mode for its surreal look. You can also share your success quickly on Facebook and Twitter or e-mail it to your mom.

Coast Highway / Process

THE MOMENT This scene is the type I would normally shoot with my DSLR, as its visual interest lies in its large dynamic range and its foreground to background range. You can see from the originals that neither image captures the expanse of the scene. But the two frames help bring together its charm. **THE PROCESSING** I did not use a tripod but did hold my breath, which I find helps keep the camera steady. You can see a bit of misalignment in the far ocean peak, but generally it is pretty good! I used ProHDR on this one and tweaked the image results with its excellent post tools.

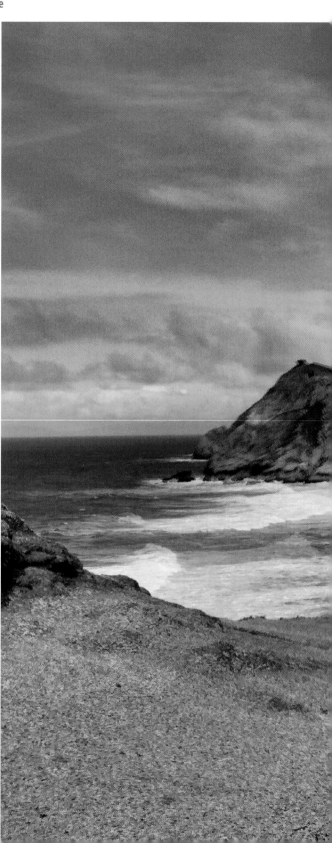

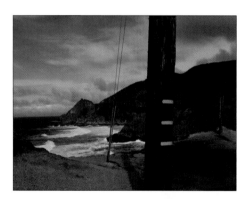

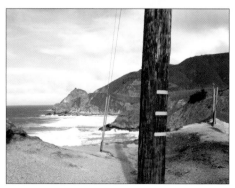

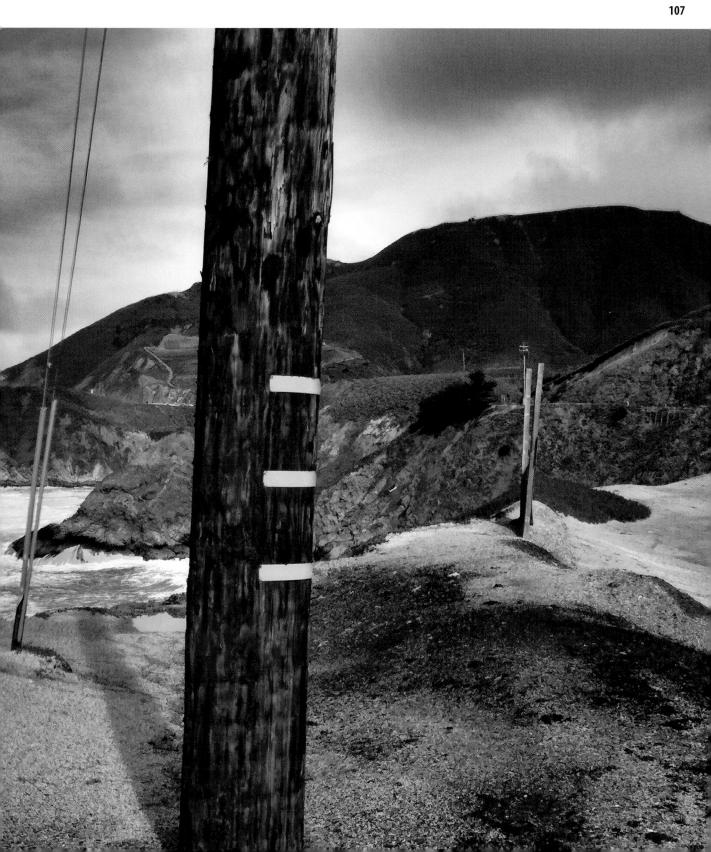

Experiments in HDR / Process

THE MOMENT Here are two creative ways to use HDR. These were images that I did not plan to process with HDR but found in my library. Sometimes when you are shooting, just take a few exposures of the same subject for later consideration. **THE PROCESSING** The image below combines two frames, giving a double-exposed look. The image to the right combines two frames that were intentionally offset. This lends the feeling of motion.

Leaving Victoria

STEP 1 ProHDR Choose two similar frames from photo library. Merge and tweak color and brightness.

STEP 2 PictureShow
(CHAPTER 11) Convert to sepia tone and add smoky light effect, vignette, and noise.

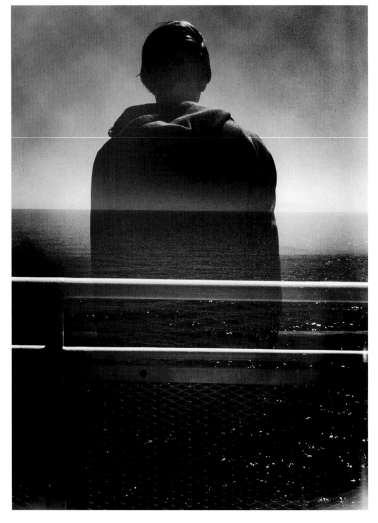

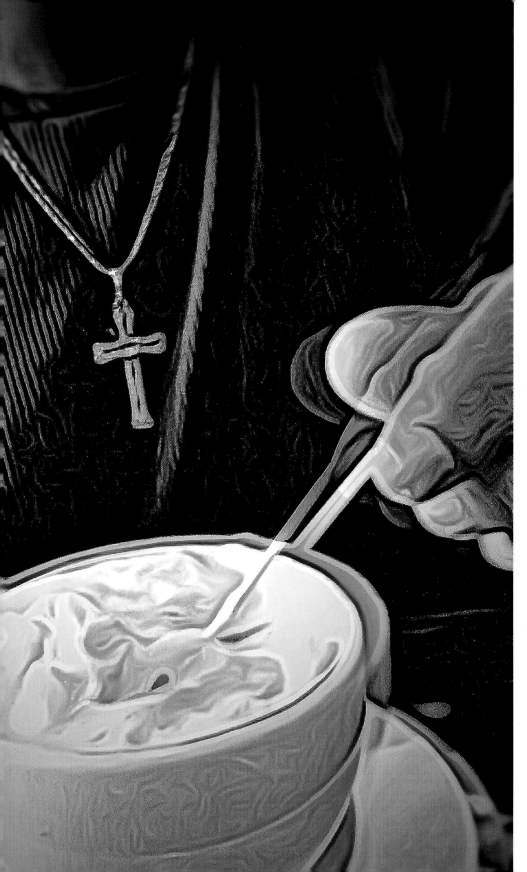

Andre Latte

STEP 1 ProHDR Choose two similar frames from photo library. Merge and tweak color and brightness.

STEP 2 ToonPaint (CHAPTER 5) Create a black and gray toon line version of step 1.

STEP 3 DXP (CHAPTER 2) Combine HDR version with toon version using multiply.

STEP 4 TiltShift (CHAPTER 4) Blur edges and increase saturation.

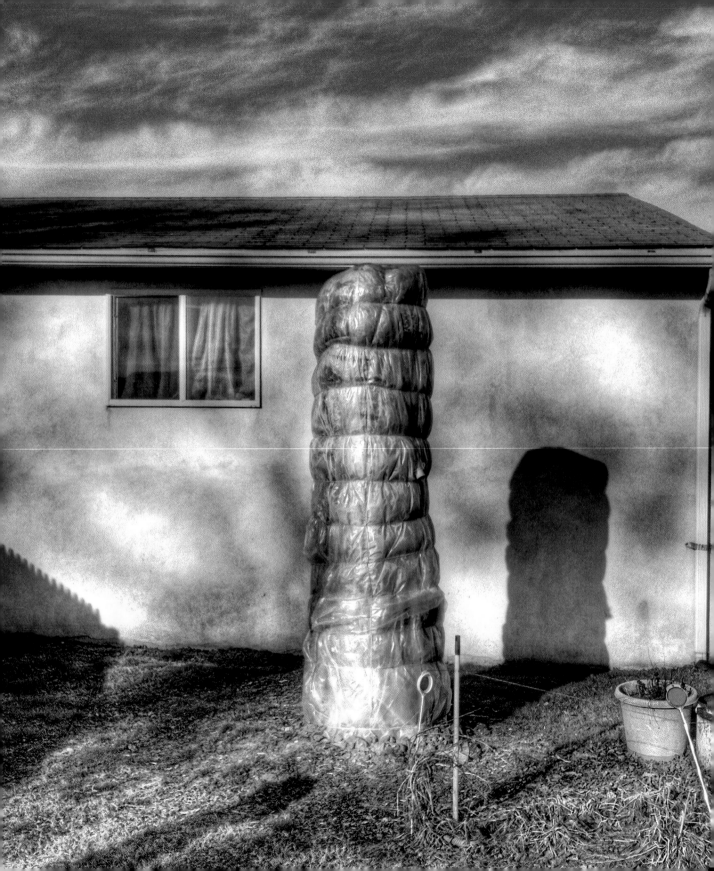

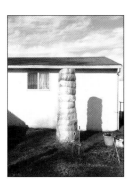 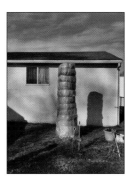

Wrapped Trees

STEP 1 TrueHDR Merge
two exposures using the
enhanced mode.

STEP 2 Photoshop Express
(CHAPTER 2) Sharpen and
increase the saturation.

TIP TAG *Scan the tag to see*
some apps and
accessories to help take
better HDR images.

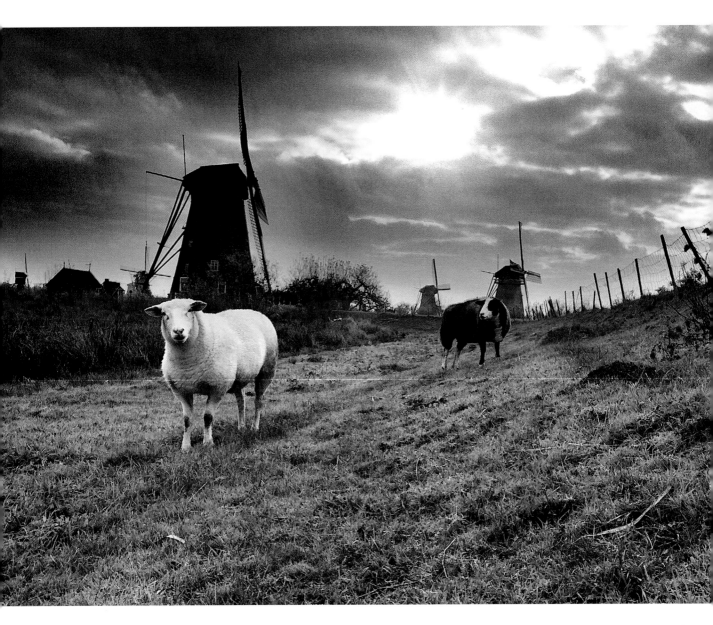

Kinderdijk Morning

STEP 1 ProHDR Merge two exposures and tweak color and contrast.

STEP 2 PhotoFX (CHAPTER 2) Selectively enhance the sky color through a mask with a polarizing filter, add film grain, and sharpen foreground.

STEP 3 LensFlare (CHAPTER 10) Enhance sunlight with subtle lens flare.

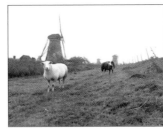

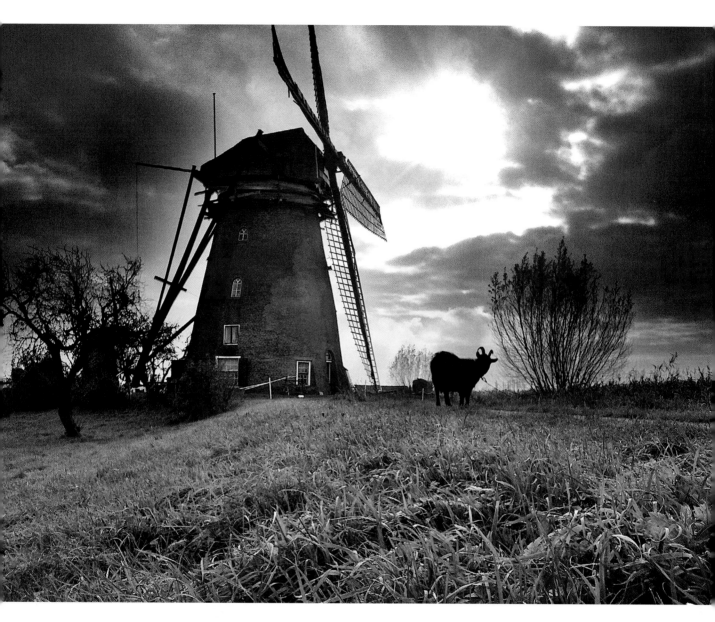

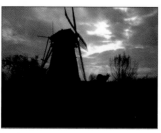

On my trip to Kinderdijk in the Netherlands, the clouds broke for just a minute. I really did not expect much from the shots, but when I ran them through ProHDR they were completely transformed.

TIP TAG

Beach Boulevard / Variations

THE MOMENT It was one of those mornings; things were very overcast, and I was afraid my photo journey to the coast was in vain. Then the sun broke for a moment and I decided to try some HDR exposures. I was stunned by the results. **THE PROCESSING** I was very pleased with what I got out of ProHDR and then even happier after selectively altering exposure and color in PhotoFX. Then I really put this image through the app mill, using ToonPaint, TiltShift, DXP, and a bit of FX Photo Studio! **SCAN THE TAG TO SEE THE PROCESS AND APPS USED**

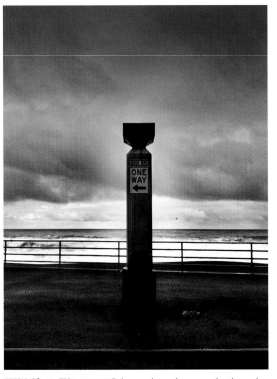

STEP 1 ProHDR Merge two exposures; tweak color and contrast.

STEP 2 PhotoFX (CHAPTER 2) Enhance sky and ocean color through a mask with polarizing filter, add film grain, and sharpen foreground.

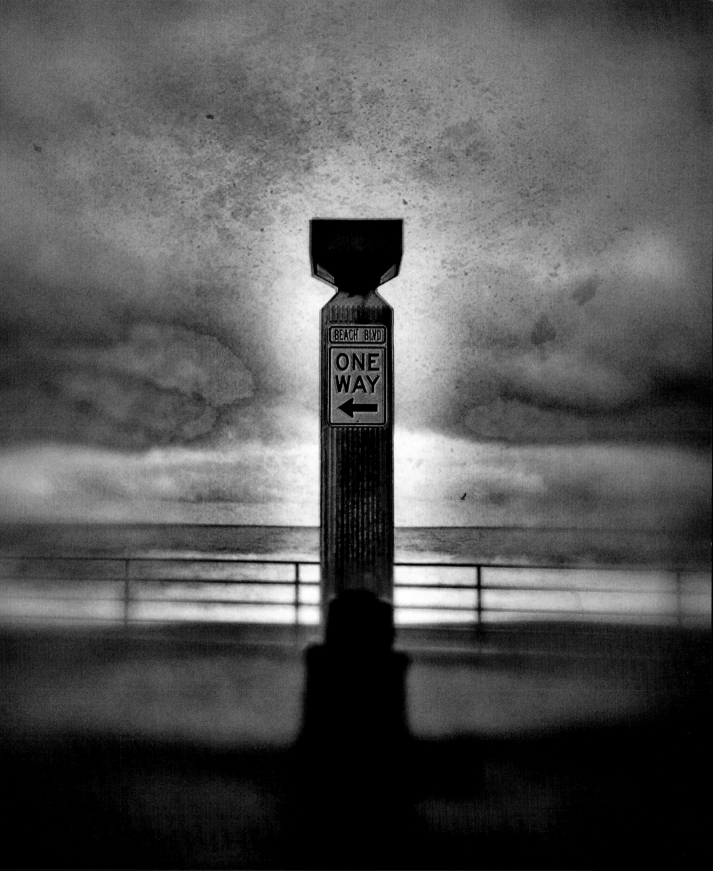

Scan the tags next to the app icons and see a short video from the author explaining each app's key concepts. In addition, you will have access to the iTunes download link and developer's Web site. The tag urls are also included in the Links Glossary on page 174.

Chapter 9 Breakouts

These apps segment, dissect, and combine images. By doing this to your images you can create more complete stories or imply a message through a juxtaposition of subjects. Or by segmenting them you can simply create interesting design compositions. As always, you can pretreat an image in an app before you combine it to create another level of attitude.

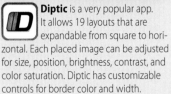 **Diptic** is a very popular app. It allows 19 layouts that are expandable from square to horizontal. Each placed image can be adjusted for size, position, brightness, contrast, and color saturation. Diptic has customizable controls for border color and width.

QuadCamera creates one image from four to eight sequential shots. You can capture many angles of a moment quickly. When the images are processed into one of the four grids, the results can be interesting from a design and a story standpoint. It also has an animation mode and color filtering.

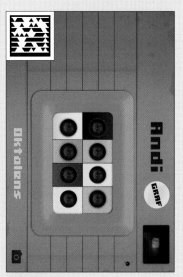

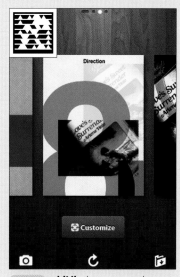

LoFi is a celebration of imperfection. Cross-processing, also known as x-pro, is the art of developing film in the most untraditional ways to produce the most untraditionally wonderful photos. LoFi has 12 unique processing styles along with five grid layouts you can drop different images into, creating high-energy compositions.

Andigraf uses four lens layouts, capturing your story in one shot. You can change lenses and film with the swipe of your finger. You can give the images different looks by changing to one of nine film types like Redscale, Classic Sepia, or Warhola Candy Color. Go manual or vary the shutter speeds, depending on your subject.

addLib changes your photos into beautiful graphic design layouts. It mixes type and image together using the grid system, fractal theory, and a facial recognition system, producing interesting compositions. As someone who's been designing for 25 years, I am very often impressed with the output of this app.

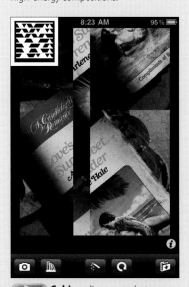

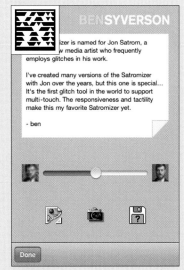

Cubism dices up a photo, randomly sliding parts horizontally and vertically. You know the way a mistake sometimes looks beautiful? Well, this app allows you to generate many mistakes quickly till you end up with something beautiful.

Satromizer takes its name from Chicago artist Jon Satrom, who frequently employs glitches in his work. I have always loved the look of a digital file that has gone corrupt. This app gives you random colored pixels, misaligned parts, and areas of changing color. With just the right amount of distortion, the result can be both arresting and editorial.

TIP TAG

Church and State / Process

THE MOMENT Some of my favorite shot spots are weekend garage sales. There's just something about the random juxtaposition of object types, from religious icons to well-read trashy romance novels, that catches my interest. Also, indoor items brought out in the bright sunlight take on a different personality in their new context.

THE PROCESSING I really was not trying to make any great statement with this image. It just so happened that the two items were on the same table in the same lighting conditions. By cropping them tight and giving them an extreme color look, without trying, I think I may have made a statement. **SCAN THE TAG TO SEE THE PROCESS**

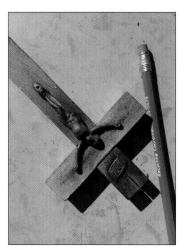

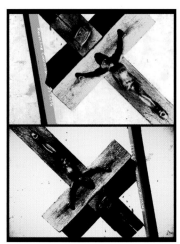

Photoshop Express Crop and brighten both images.

LoFi Try many grid combinations of the two images with different cross-processing styles. It's best to work quickly and on impulse, then review output choices later.

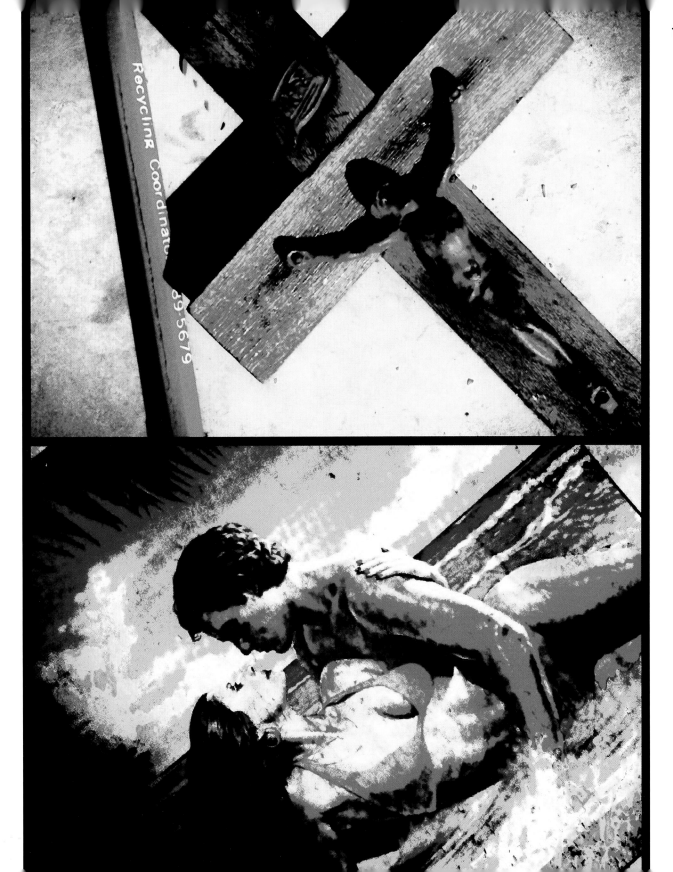

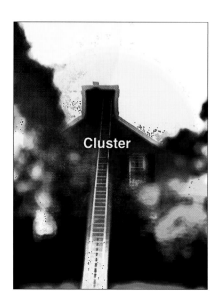

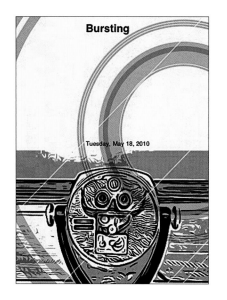

ALL IMAGES addLib Random-generation series.

Saturday, April 17, 2010
Vivid

Fancy

Tempting

The random text mode sometimes creates intriguing word and image combinations, but don't forget to try the custom text option.

Old Retreads **QuadCamera** Choose Vivid with vignetting on.

 Scan the tag to see a few movies (GIF animations) created with this app.

Caddy **STEP 1 QuadCamera** Select hi-con with vignetting.
STEP 2 CameraKit (CHAPTER 4) Use the sepia setting.

TIP TAG

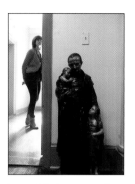

Catholic School Days / Process

THE MOMENT While touring this old-school Catholic school, I had some flashbacks to my childhood. The religious statues that stood about seemed a bit eerie to me now. **THE PROCESSING** I tried to convey the feeling of a distant memory. To do this I first processed the images in TiltShift, giving them a soft, dreamlike quality as an overall tone. Then by positioning and scaling in Diptic, I tried to further embellish the story line. The picture has added mystery because it uses three shots taken from the same position, but the subject has moved. **SCAN THE TAG TO SEE THE PROCESS**

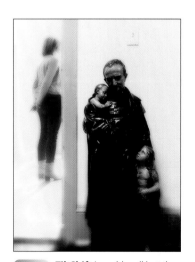

TiltShift Lens-blur all but the statue and light switch on three frames. Add saturation and blooming effect to highlights with hexagon aperture shape.

FilmLab Alter the color tone with the setting HDR and orange-blue. Use tools to sharpen.

Diptic Try various layout arrangements, scale images for emphasis, and brighten images where necessary. Change border framing to black and a bit thinner.

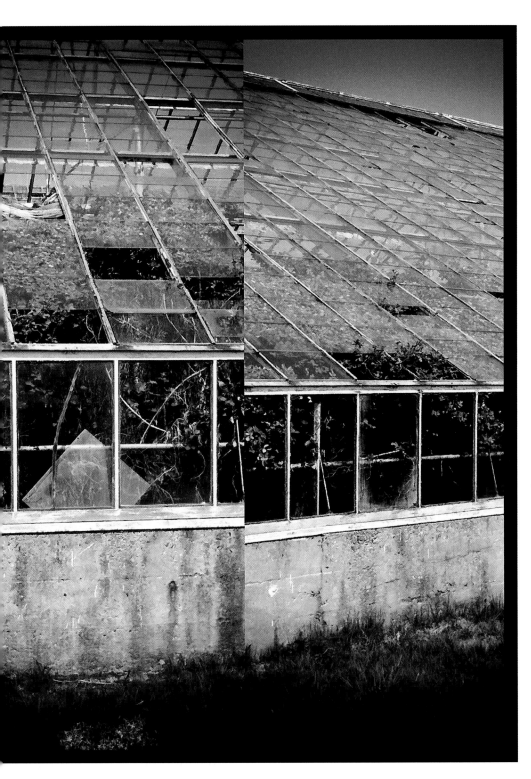

The Rose Factory
Andigraf I used the Quadling lens with Edie film type.

With Andigraf you can stand in one spot and rotate the camera between exposures, giving the resulting picture a wide-angle distortion feeling.

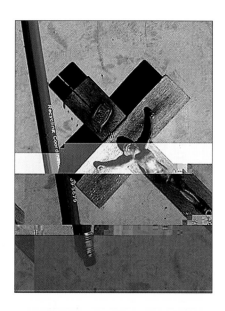

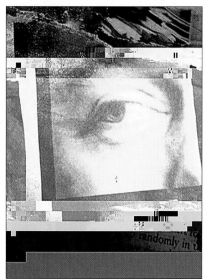

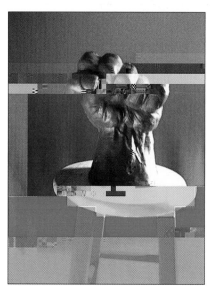

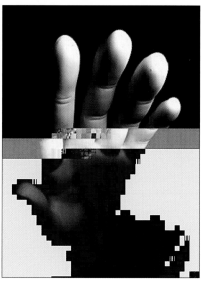

ALL IMAGES Satromizer Random-generation series.

Ikea Stop Sign

STEP 1 ProHDR (CHAPTER 8)
Merge two exposures;
tweak color and contrast.

STEP 2 Cubism Random
generation of options.

*The output from Satromizer and
addLib is very low resolution—
only 320 by 240 pixels—so it is
best used for onscreen viewing
or very small printed output.*

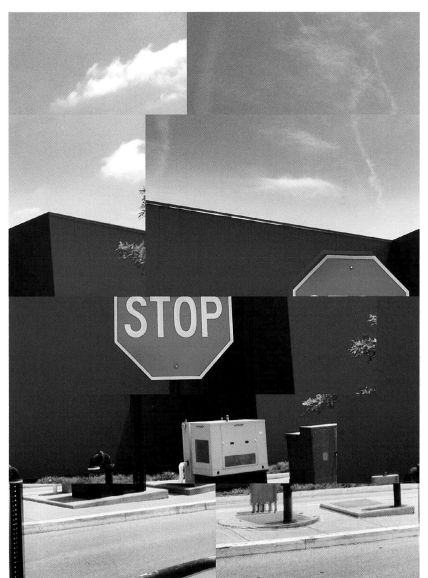

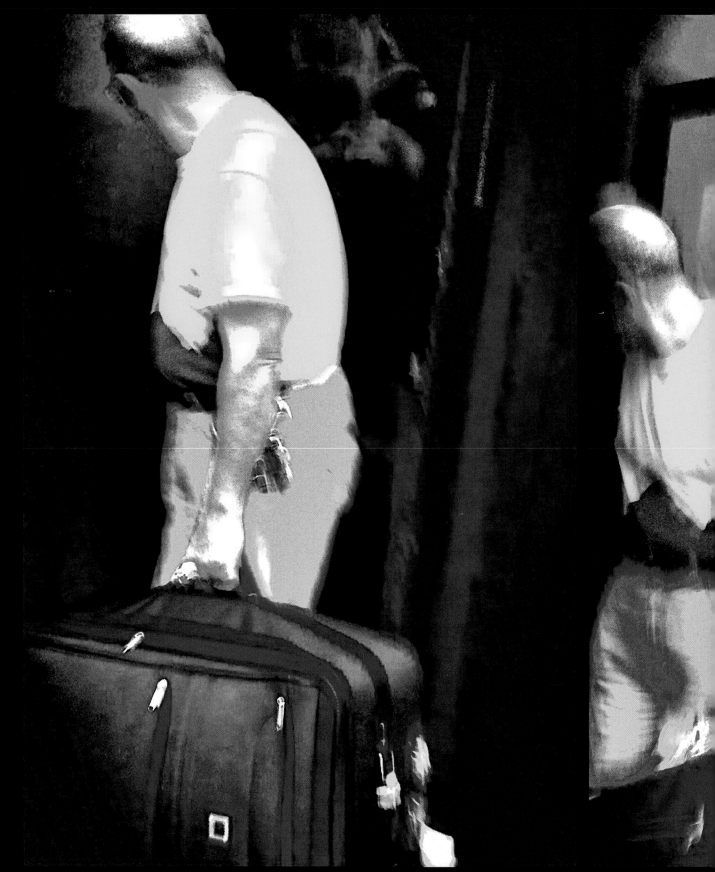

 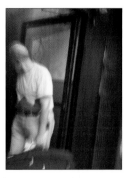

This Time It's for Good

LoFi I used the color pro setting on both images.

Quickly snapping images while you walk can give them a pleasing blur, enhancing the tension of the story.

Chapter 10 Adding Light

Scan the tags next to the app icons and see a short video from the author explaining each app's key concepts. In addition, you will have access to the iTunes download link and developer's Web site. The tag urls are also included in the Links Glossary on page 174.

Light is probably the most important directional element in a picture. It gives images their soul. So if a picture's soul can be saved by adding a little "spark" in post, then do it. But do it with restraint so it looks natural and does not come across as cheesy and potentially ruin the image. Adding light can mean adding or accentuating a sunburst with LensFlare or adding a glowing morning cloud with the app called Light or even simulating an old plastic camera defect, such as adding a light leak along the edge of an image.

 LensFlare adds realistic light bursts to your images. This app is very well conceived, like some of the high-end software I use in my video work. It has 24 preset flares with control over brightness, position, and size. The thing that makes it very convincing is that when you reposition the light, the angle and spread of the optical artifacts change.

Lens dust included The home screen actually is animated and feels alive. Here you have control of brightness, flare type, and position. You can even add lens dust.

See the light With some 24 preset effects, you have different colors, intensity, and optical qualities to explore. Some lights have intense outer fringe effects, and some just add a glow to one spot.

Position is interactive Depending on how far from the center of the image you move the light or if you move it past the edge, the fringe, glow, rings, and beams change organically like real lens flare.

 Light can add light to a scene where none existed before. Although it is not as physically real as LensFlare, it has some really clever controls to shape the light into a believable form. This developer is respected for its professional plug-ins for high-end desktop image and video applications. You can actually buy Light for your Mac.

Gobos to go Gobos, or patterns, are used by film lighting designers to create atmosphere. It includes 117 of them, such as breakups, foliage, lights, sky, and windows.

Displacement is the key You can control light, brightness, and blurring; the displacement feature is unique for creating the illusion of light wrapping around contours.

Isolate light Using the source as a control, you can affect how the brightness of the light hits certain areas. Also, you can mask areas easily.

 LightLeak simulates an old plastic camera leaking light onto the film. I have a large collection of plastic toy cameras, and part of what I loved about them was the random way light affects the edge of the film. Something about it brings another layer to the story—it breaks the picture's illusion and adds realism and fragility.

Images pop Images can be processed in color or black and white. A small amount of extra contrast is added to produce rich graphic images.

Random accidents It's a good idea to try running the effect a couple different times because it is random and another rendition might suit the picture better.

Really blow it out As an alternative to running the effect more than once, preprocess the image in FilmLab or FotoMuse first.

TIP TAG

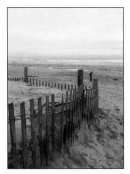

Surf City / Process

THE MOMENT I shot this while I was checking the surf, and I didn't think much of it when I took it. It wasn't till later that I noticed the father and child beyond the fence. It has become one of my favorites. Trust your instincts when you get the urge to take a picture; don't always ask yourself the reason for doing it. **THE PROCESSING** This image uses a combination of techniques from previous chapters, but the final touch was adding what is known as God rays with the app Light. You can see this effect in the upper right-hand corner of this picture. **SCAN THE TAG TO SEE THE PROCESS**

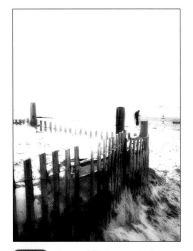

CameraKit Process the image with black-and-white film with the flash setting on, soft focus set to level 2, and push processing set to 1.

fM **FotoMuse** Apply a grunge border and texture. Explore several options.

Light Choose light rays 2 from the Lights section. Scale to fit naturally in the corner. Set brightness to level 140 and blur to level 25.

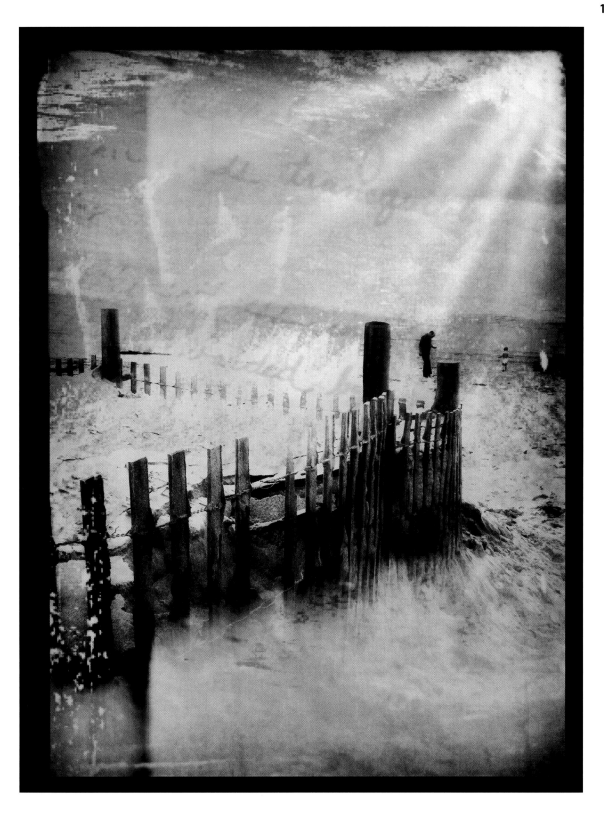

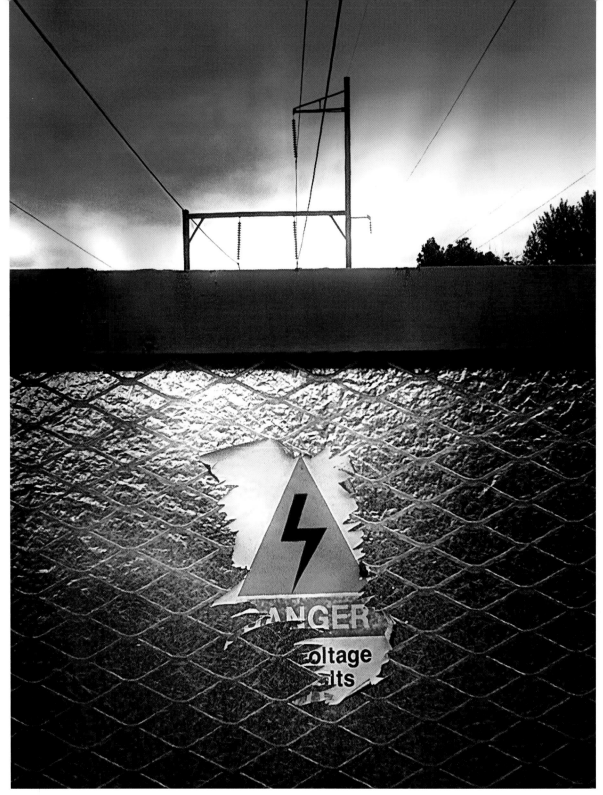

Anger Voltage **STEP 1 PhotoFX (CHAPTER 2)** Selectively darken the sky; increase saturation. **STEP 2 Light** Use light rays, rotate, brighten, and blur.

Add lens flare with restraint so it looks natural and does not come across as cheesy and potentially ruin the image.

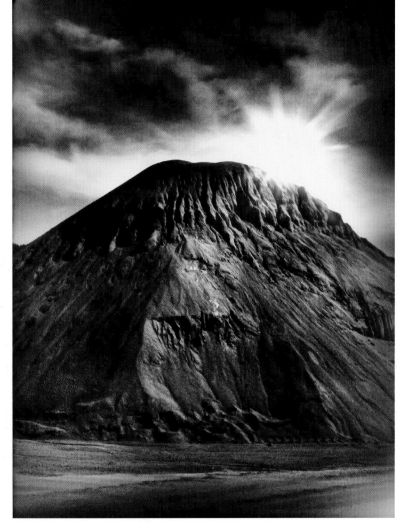

Corsan's Quarry **STEP 1 ProHDR** (CHAPTER 8) Combine two exposures.

STEP 2 FilmLab (CHAPTER 6) Use blue-black conversion and sharpen.

STEP 3 ProHDR Use chroma ring setting; scale and brighten.

The light was not great where I found these old ads. So I enhanced the drama by shining a small high-powered LED flashlight across their surface.

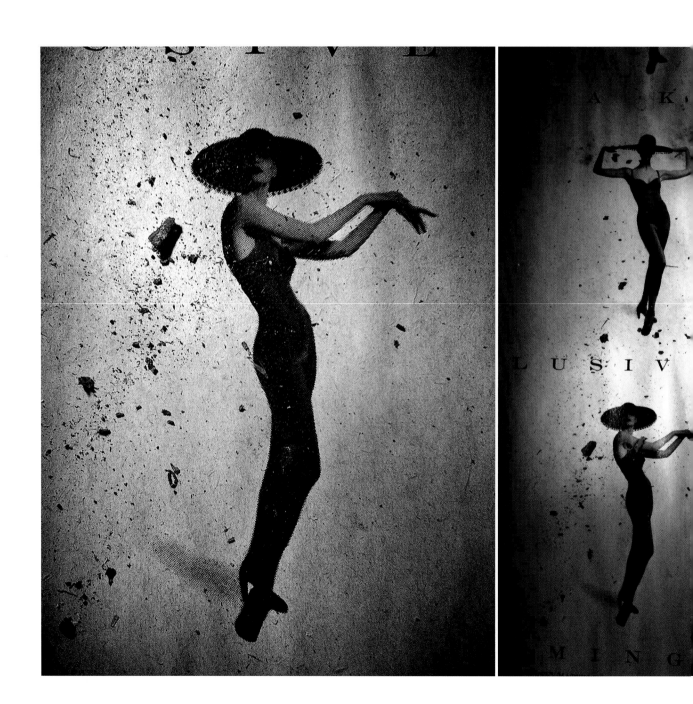

It is the contrast of the dramatic elegance of the original image with the crumbling paper that gives this picture its interest.

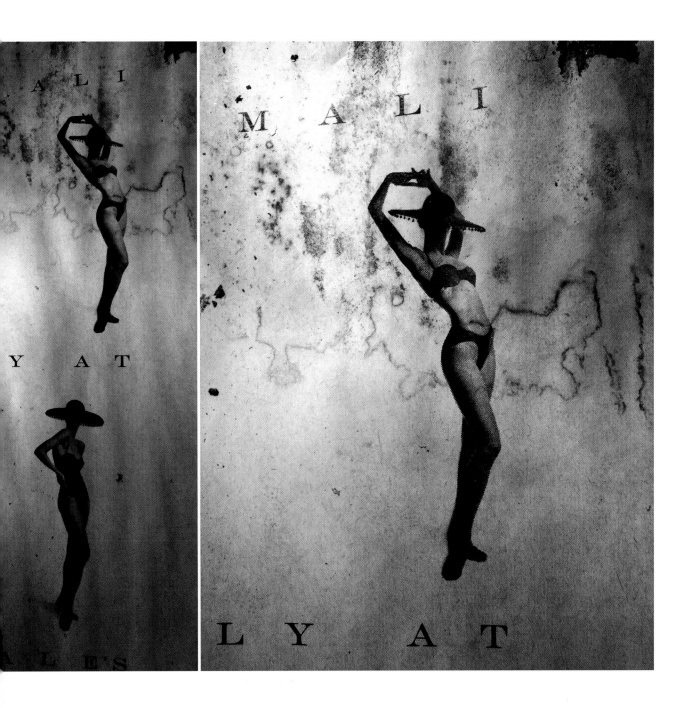

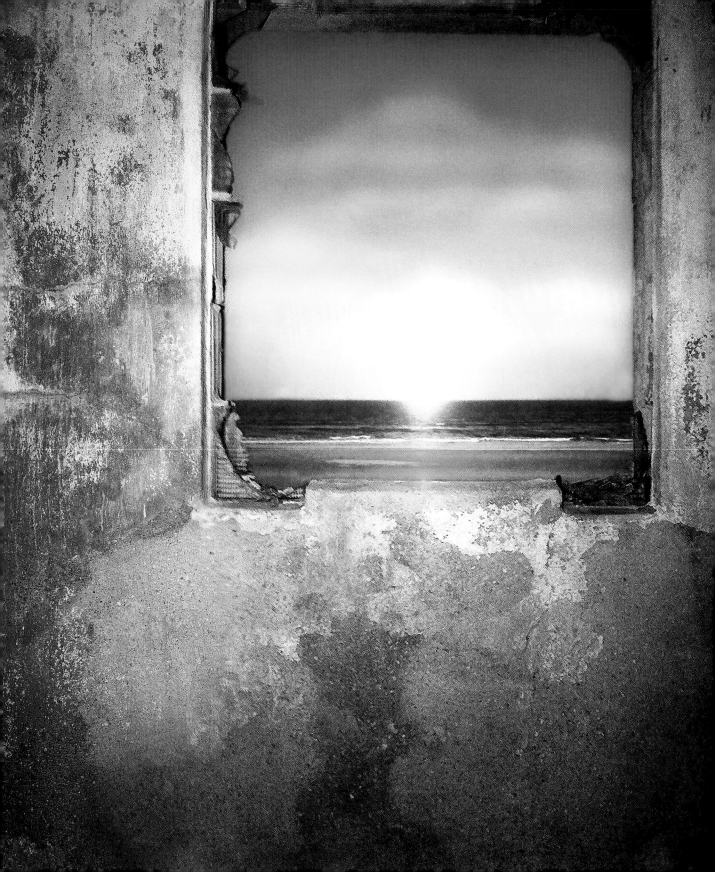

Window to the Sea / Process

THE MOMENT OK, so I cheated on this one. This picture is actually of an old print of mine that hangs in my home. I had taken it some 20 years ago with my medium format film camera. **THE PROCESSING** I took a picture of a picture and brought new life to it through iPhone processing! It was a little more involved, since I had to remove my reflection from the glass in the frame. I used Touch Retouch for this, and it gave me a clean sky where I added some soft clouds I always thought it needed using Light.

Don't be afraid of bringing in other photos from other sources. Try the app Pic Transfer or CameraSync.
APP TAG
Scan the tag to read more.

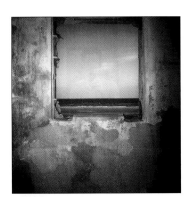

 Touch Retouch Look closely and you'll see my reflection in the frame's glass. I used the lasso to roughly outline the sky area, then zoomed in and used the brush to refine the edge.

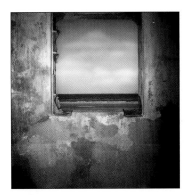

 Light From the sky selection of gobos I chose cloud 1. I blurred it to level 40 and lowered the brightness to 40. The position slider can also be controlled by dragging your figure over the picture area.

 PhotoFX Using the masking capabilities, I softened and saturated the sky and water areas, and reversed the mask to sharpen and add contrast to the wall areas. I added overall film grain to the picture to blend it all together.

Summer's Last Dive / Process

THE MOMENT I admit you will see a few too many windmills in this book. But the images surprised me—the day was completely gray and cold with no light, and I didn't expect much from my iPhone. There was about an hour when the clouds broke just a bit, though, and I was at the right spot. **THE PROCESSING** Bracing the camera against the ground I snapped a series of HDR pics as I slowly approached the sheep seen in the distance. (You can review how the images were prepped in Chapter 8.) The tipping point on the image shown here was adding the white light lens optic with LensFlare. You can really see the lifelike light rings and artifacts in this example.

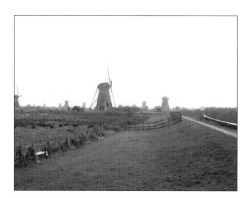

Original image

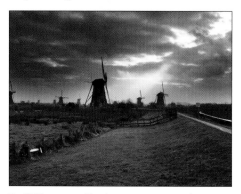

ProHDR (CHAPTER 8) Blend two exposures together.

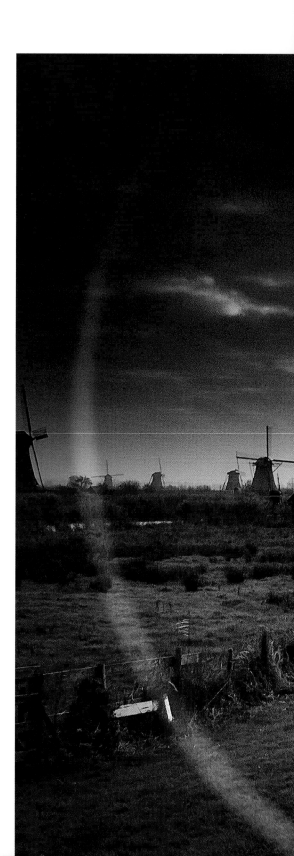

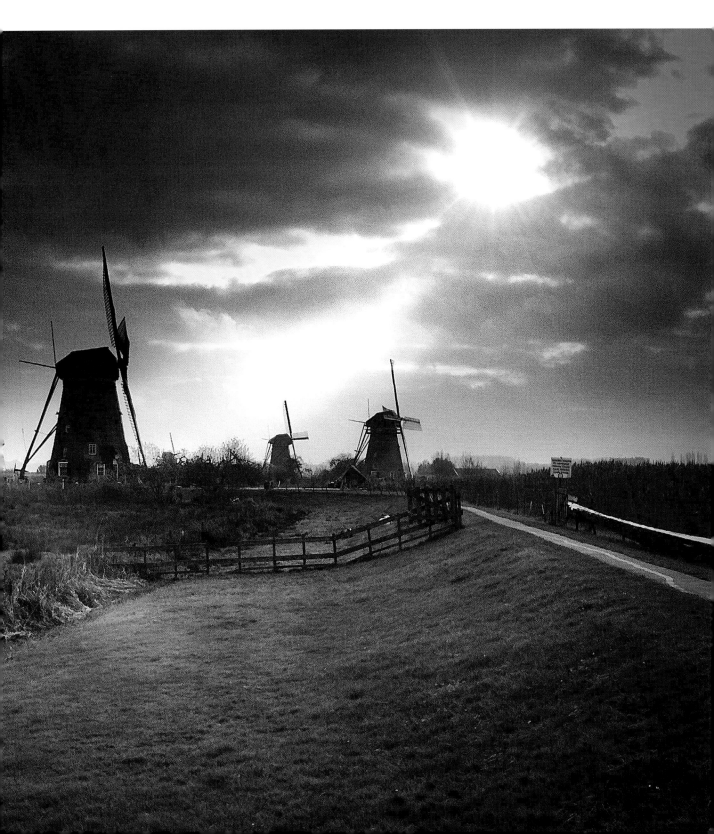

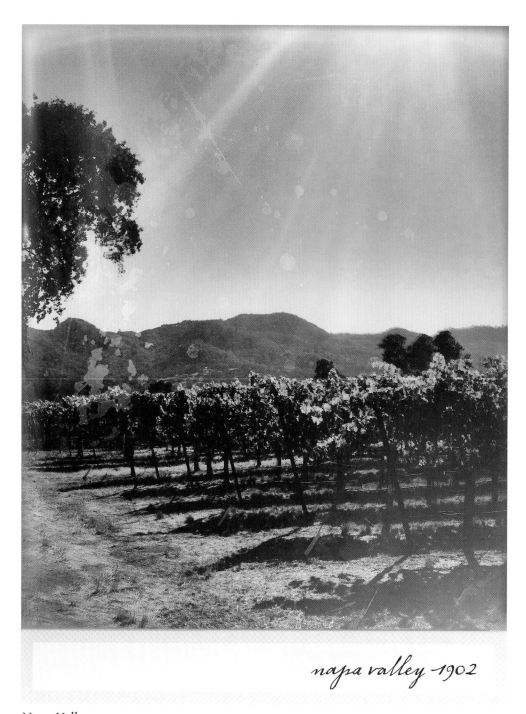

napa valley 1902

Napa Valley **STEP 1 ProHDR** (CHAPTER 8) Blend two exposures together. **STEP 2 PictureShow** (CHAPTER 11) Use yellow gel, instant frame, light leak 8, paint drop noise, and vignette. **STEP 3 Light** Use light rays 3, blur, and scale.

Summer Laundry **LightLeak** Random effect generation.

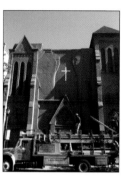

Redemption / Process

THE MOMENT Getting out of my car in Hoboken, New Jersey, for a meeting, I glanced directly across the street to see this picture coming together. I quickly hung up from my call and turned on my camera. The angle of the sun and the position of the worker's body came together in just seconds. I was able to take a few shots as he walked the length of the truck. But none were as good as him pushing the ladder directly below the cross.

THE PROCESSING I wanted to emphasize the graphic qualities of the image, so I first converted it to monotone using CameraKit. The light is the key to this image, not only because it helps define the shapes but because it reinforces the heavenliness of the story. The CameraKit processing gave the highlights a nice glow, but LensFlare used in the upper right really accented the God rays. **SCAN THE TAG TO SEE THE PROCESS**

If you see a moment coming together quickly, take a shot as soon as your camera comes on so you get something. But don't settle for just one shot—let the moment develop. It may surprise you.

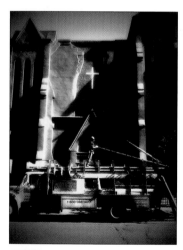

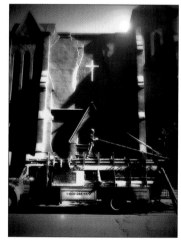

CameraKit Use sepia film setting along with vignetting and flash on. Put soft focus to level 3 and push process to level 2.

LensFlare Experiment with different lens optics and positions for the burst. Choose desert sun preset and bring up brightness.

Chapter 11 Auto Effects

Scan the tags next to the app icons and see a short video from the author explaining each app's key concepts. In addition, you will have access to the iTunes download link and developer's Web site. The tag urls are also included in the Links Glossary on page 174.

So if you don't have much time or you are not quite as obsessed as I am with finding crazy ways to combine apps for kicks, you can turn to this instantly gratifying group of apps. They combine some of the best grunge, paint, light, toon, and blur effects so you don't have to remember everything you learned in this book! And even better, they can randomly combine all these parameters so you can uncover your images' inner tone by sheer good luck. They also have some hidden abilities to customize your final effect, so the best thing to do is get your image close with randomize and then fine-tune some versions.

 PictureShow randomly combines one of 28 photo styles with five color editing parameters plus four style attributes, each with about 12 variations, and a type layer with four attributes. You can get some pretty varied and interesting results quickly and then fine-tune your results.

Random madness The random mode can really give you some great inspirations, and I end up saving way too many options for one picture.

Sanity returns Let's say you find a random look that is close but you don't like the frame that was used. You can then pull up the menu and change it or turn it off.

Endless bliss So if I was stranded on a desert island and only had one app, PictureShow would probably be the one. Of course, I would also need a solar charger.

 LoMob brings lo-fi and photographic experimentations to your mobile pictures. When I first discovered this app I could not use anything else for a month. It has a really unusual collection of offbeat analog simulations, touching more on the alternative fine art side of photography but with just enough control to make the results your own.

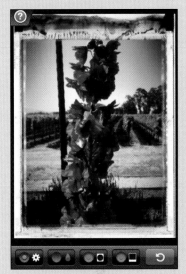

Quirky cool If I created an app it would be something like LoMob. It has some quirky FXs like through the viewfinder (TTV), glass contact sheet, and square vintage styles.

Preview possibilities Take a picture or choose one from your library: LoMob will process it and give you a preview of all its 39 filters at once.

Just enough control It is not completely evident that you can refine the effects, but after choosing a preset, touch the picture and up comes the submenu.

 CameraBag enhances your photos in a very elegant and easy-to-use way. If I want to quickly give a photo a tasteful artistic infusion I turn to CameraBag. It has been around for a while, but its simplicity and restraint of effect make it a classic must-have app.

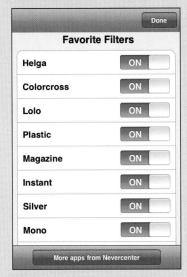

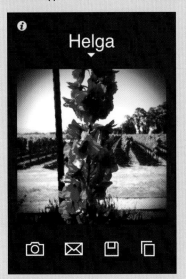

Restraint To streamline your processing experience turn off effects you never use (like fisheye). You can also choose to turn off cropping and borders.

Swipe away your blues The simple method of swiping instantly reveals the next effect preview. Once you see what you like, hit save.

A little variation If you want a slight alternative from the well-conceived presets, you can double-tap the image. Mac and PC versions are also available.

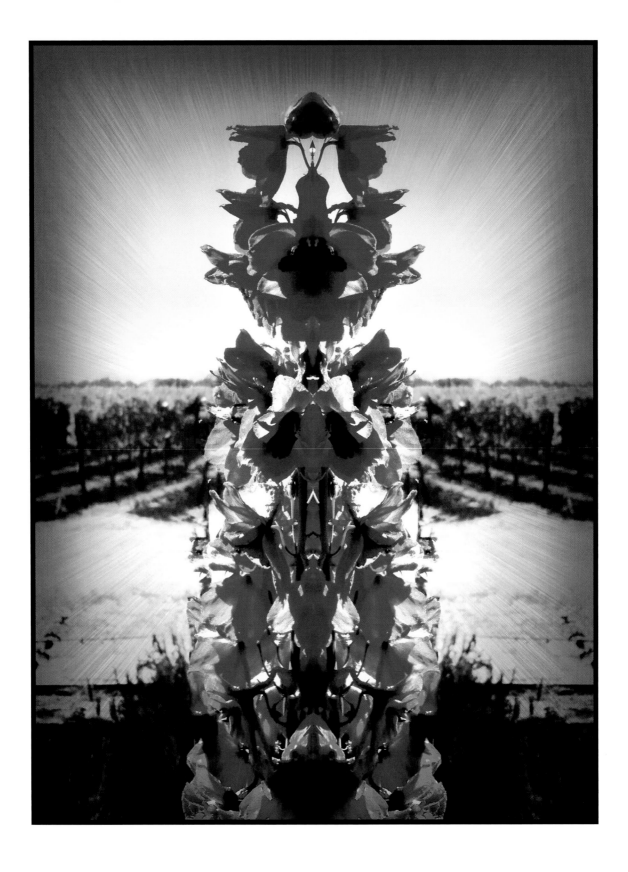

TIP TAG

Napa Reflections / Process

THE MOMENT Traveling through Napa Valley I got lots of pretty pictures. But pretty pictures don't really satisfy me—I am always looking for that unexpected moment. Sometimes the image doesn't really click until I play with it a little in an app. **THE PROCESSING** The flowers were nice when I shot them while sipping my wine, but they didn't become interesting until the next day after this iteration appeared randomly in Picture-Show. After seeing the mirror effect on the flower I knew I had something intriguing; the only problem was the support rod you can see in the original. This is where Touch Retouch comes in handy. I simply painted over the rod, and presto it was gone. Then I took the image back into PictureShow to finish it off.

SCAN THE TAG TO SEE THE PROCESS

Use the random mode in PictureShow until you get something you like. Then you can fine-tune it using the very intuitive interface.

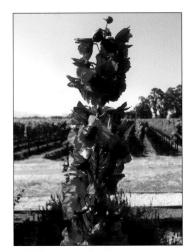

 Touch Retouch I don't use it often but it is a quick way to solve a problem in a photo. I used the paint brush and zooming in covered over the rod with just a little overlap.

PictureShow Use mirror setting, black frame, no light leak, zoom noise, vignette, and add contrast along with intensifying the blue.

Warhol **PictureShow** Use yellow gel, no frame, light leak 2, and scratch noise and alter color and contrast.

Save Me **PictureShow** Use vivid setting, no frame, light leak 5, and rub noise and alter color and contrast.

These three examples were taken in very low light, which increases the noise, blurring, and color aberrations, but with the right subject it can work in your favor.

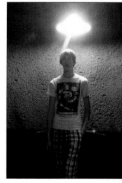

Under Suspicion **PictureShow** Use vintage yellow setting, white frame, light leak 5, scratch hard noise and alter color.

Frozen in Time **STEP 1 CameraBag** Helga variation. **STEP 2 FilmLab** (CHAPTER 6) Use arrowtown fade film conversion.

CameraBag has a hidden random option. By double-tapping on an image you can get endless variations with each of its 13 presets.

Salt Mound **CameraBag** Use the Helga setting with cropping on.

APP TAG

Scan this tag to see an image collection shot with toy cameras and real film, where many of these app effects were used.

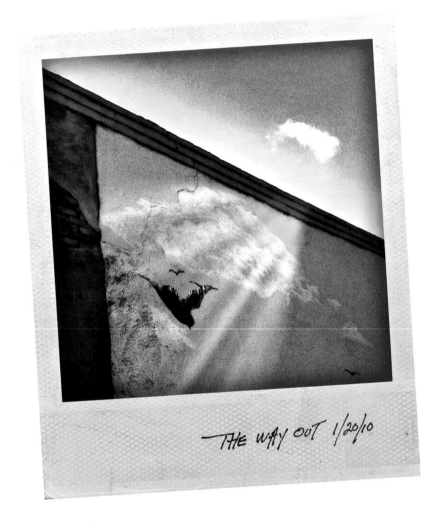

Coastal Cruiser

PictureShow Use vintage blue, vintage stain frame, no light leak, sand noise, and vignette.

LoMob has over 40 really nice presets, but take note that you also have five somewhat hidden subcontrols including scaling and moving the image within each frame.

The Way Out

STEP 1 Photoshop Express (CHAPTER 2) Brighten, add contrast, saturate, and sharpen.

STEP 2 Light (CHAPTER 10) Add sun rays in perspective.

STEP 3 LoMob Use the family instant 2 preset; use frame but turn off color effects.

STEP 4 DXP (CHAPTER 2) Add a picture of handwriting using multiple blend mode.

Faraway

STEP 1 Photoshop (DESKTOP) Resize original DSLR image to 2500 pixels wide and e-mail JPEG to iPhone.

STEP 2 PictureShow Use noir setting, no frame, no light leak, and rust noise; add vignette and contrast and lower brightness.

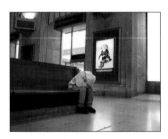

Resolution is key to clarity in your pictures—always try to work at the maximum settings in your apps.

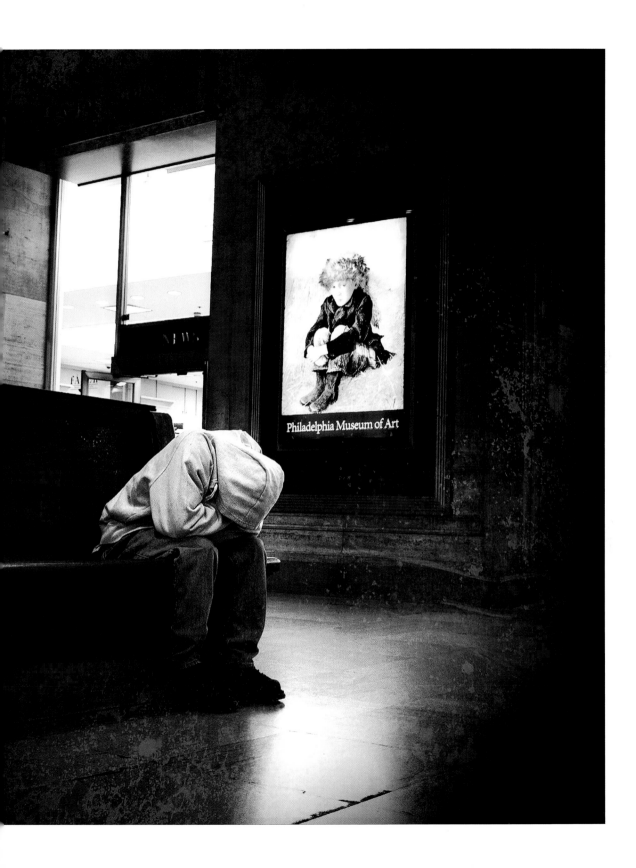

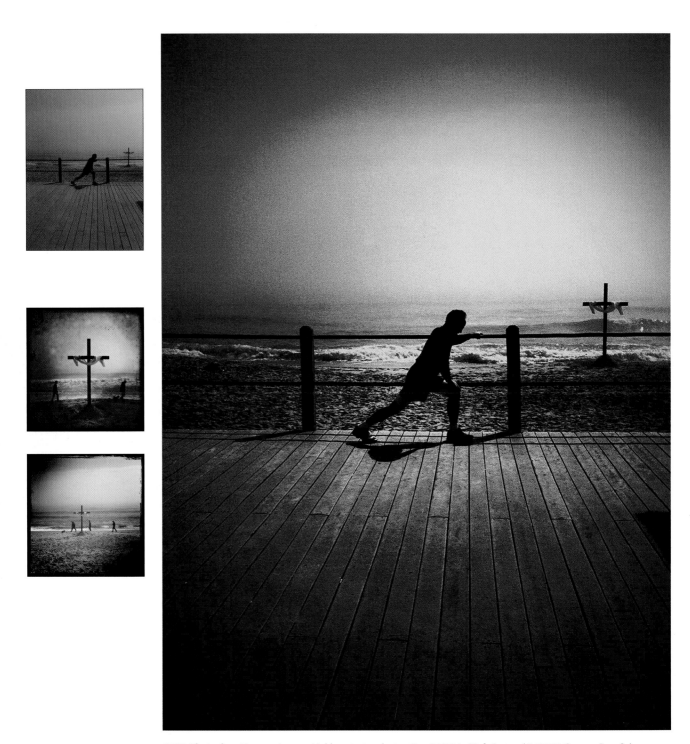

STEP 1 Photoshop Express (CHAPTER 2) Add contrast and saturation. **STEP 2 LoMob** Postcard 3. **STEP 3 CameraBag** Colorcross.

Easter Morning Surf Check / Series

THE MOMENT Again I was checking the surf. This time it was Easter morning.
When I got to the beach I was stunned to see this massive cross planted in
the sand. The waves could wait—I had to capture the feeling of this day.
I shot the scene from many angles. The best shots, though, seemed to be the
ones that included people, I think because they gave a sense of scale to the
cross. **THE PROCESSING** For the two images below I wanted to push the feeling of
the atmosphere, the spring warmth in the air, and the graphic qualities of the
silhouettes, so I converted to black and white, added God rays light and gave
them an otherworldly glow by running them through LoMob.

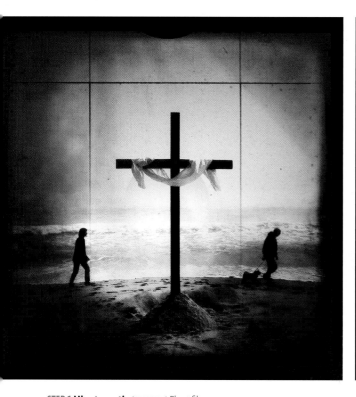

STEP 1 Hipstamatic (CHAPTER 6) Float film.
STEP 2 Photoshop Express (CHAPTER 2) Convert to black and white.
STEP 3 Light (CHAPTER 10) Add God rays.
STEP 4 LoMob Use 6x6 TTV grid 70s.

STEP 1 Hipstamatic (CHAPTER 6) Use Blackeys film.
STEP 2 Photoshop Express (CHAPTER 2) Convert to black and white.
STEP 3 Light (CHAPTER 10) Add God rays.
STEP 4 LoMob Use Tri-black film.

Chapter 12 Parting Shots

In this chapter we look at some apps that I am in the process of getting to know or ones that didn't quite fit into previous chapters. In addition, a couple of iPad-only apps are included.

The app market continues to surprise me. Unexpected one-of-a-kind apps like Percolator, full-featured apps like Filterstorm, and premier players like Adobe are getting involved to elevate the creative possibilities and change what's possible on a weekly basis. Keep in mind all the images in this book were shot with the previous-generation technology of the 3GS iPhone. The iPhone 4 offers greater resolution along with lower light shooting, built-in flash, and HDR, which gives you expanded shooting range.

I have been shooting with many types of formats for over 30 years, from toy cameras like Holga and Lomo to 35mm, medium format, and 4 x 5. All along the way I have developed film and printed color and black and white in my own darkroom. I was also a very early adopter of digital technology using pre-Photoshop software like Digital Darkroom. I have used every version of Photoshop in my design business, and my images from those endeavors have appeared in many books and magazines.

I've always loved creating imagery. But shooting and processing with my iPhone has reignited my obsession with image exploration. I truly believe that as cell phone cameras improve with higher dynamic range, lower noise, and optical zoom that they will erase point-and-shoot cameras. It is the ability to see, shoot, and process on one device that is always in your pocket that makes it so.

APP TAG *Coming to iTunes The iPhone Obsessed iPad Companion app features interactive demonstrations from this book, including full explanations of the apps covered in this chapter along with some brand-new app formulas and videos with in-app Internet resources.*

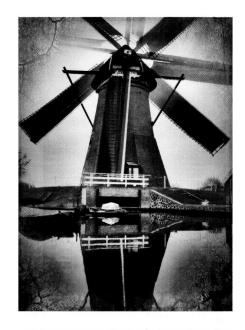

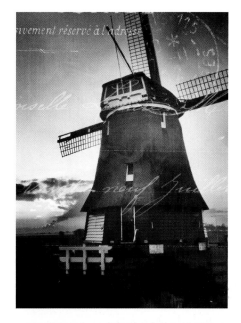

Dutch Sampler **STEP 1 Photoshop Express** (CHAPTER 2) **STEP 2 LoMob** (CHAPTER 11) **STEP 3 CameraBag** (CHAPTER 11)

 Bad Camera is an app that was inspired by the photographs of Miroslav Tichý from the Czech Republic. His work is accomplished with a pieced-together camera you have to see to believe. Create similarly styled image effects by randomizing scratches, spots, color tones, and frames. I am looking forward to seeing how this app might evolve.

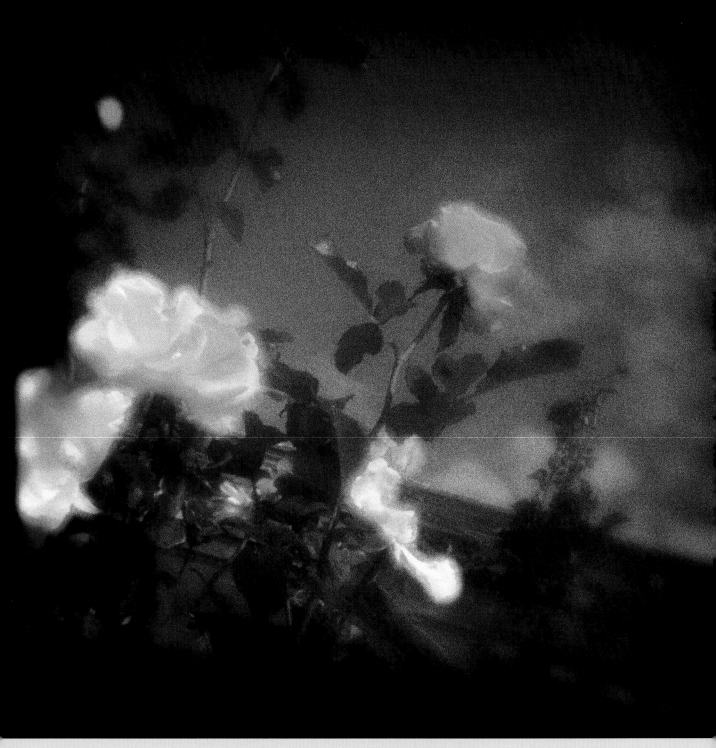

Roses and Windows **STEP 1 PinHole Camera** **STEP 2 TiltShift** (CHAPTER 4) **STEP 3 PhotoFX** (CHAPTER 2)

 PinHole Camera brings you the feeling of a simple handmade pinhole camera with all of its characteristic blurriness, saturation, and specifically dimmed margins. This app might have made it to the front of the book, but the images are super low res at 640 by 640. With a little app trickery and the right image I was able go pretty big with it here.

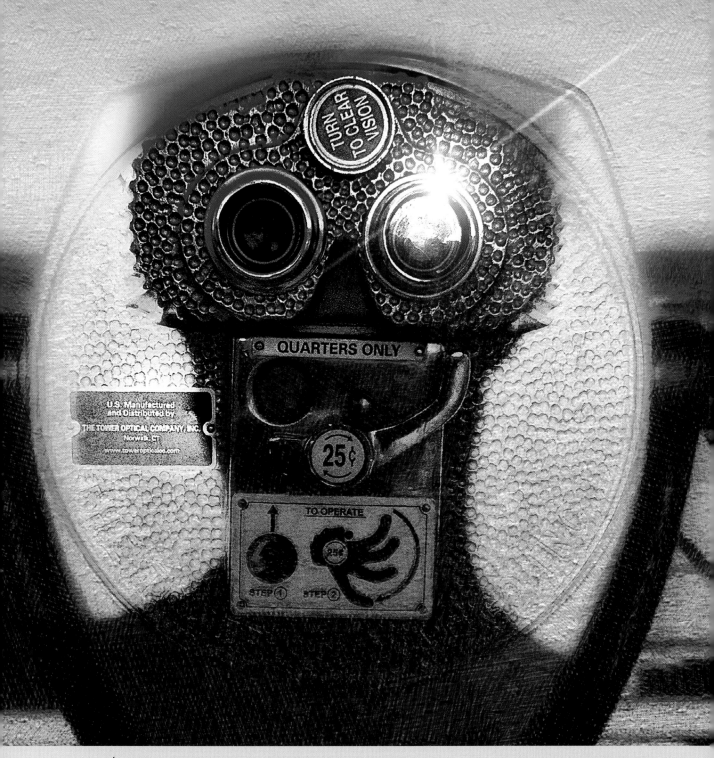

Avon **STEP 1 FilmLab** (CHAPTER 6) **STEP 2 TiltShift** (CHAPTER 4) **STEP 3 SketchMee** (CHAPTER 7) **STEP 4 LensFlare** (CHAPTER 10) **STEP 5 Filterstorm**

 Filterstorm is a fully featured suite of image manipulation tools. This app can even handle some DSLR raw image types up to 3074 by 2200 pixels. It is a great cleanup tool but not so good for effects. But it has a one-of-a-kind mask blending tool that allows you to selectively apply any manipulation. This concept on the iPad version is even better.

Fun House **STEP 1 FluidFX STEP 2 ToonPaint** (CHAPTER 5) **STEP 3 DXP** (CHAPTER 2) **STEP 4 PhotoCopier** (CHAPTER 3)

 FluidFX allows you to warp, swirl, and ignite photos from your image library. This app is powered by Academy Award–winning fluid dynamics technology, so the user experience is really nice. The output from the iPhone is limited by screen resolution, but with a few resolution hacks, you can get it to resemble a Polaroid transfer as above.

Surf Lookout **STEP 1 AutoStitch STEP 2 Iris Studio** (CHAPTER 2)

 AutoStitch automatically stitches together 2 to 20 or more images to form a seamless panorama up to 18 megabytes in size. I have owned desktop software that cost me hundreds of dollars that did not do as good of a job as this app. I also really like the interesting edge it gives to the finished image. I hope to try it with HDR images soon.

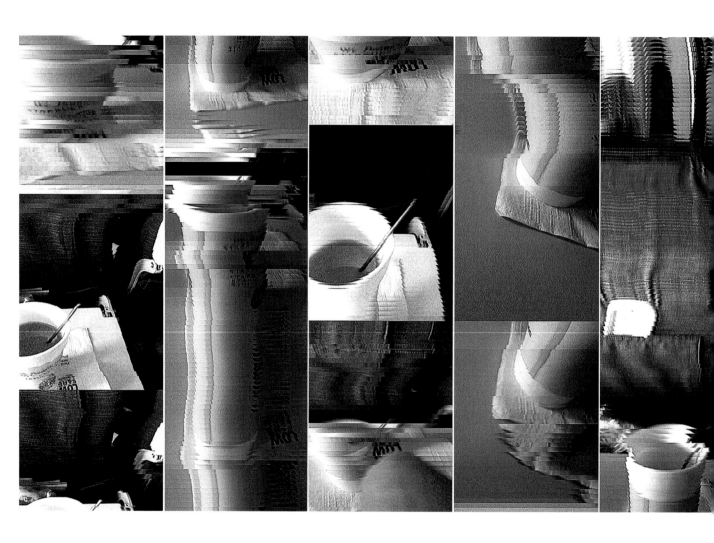

A Long Flight Home STEP 1 **TimeTracks** STEP 2 **Iris Studio** (CHAPTER 2) STEP 3 **Photoshop** (DESKTOP)

 TimeTracks turns the iPhone into a slit-screen camera. Like a scanner, it generates a unique effect over a defined duration—moving objects and changing scenes produce interesting imagery. It has settings that speed up the capture or make the slices bigger. Images are 1020 by 320, but stack them together (as shown above) to increase their impact.

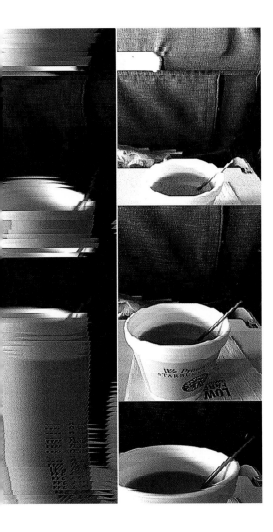

June Lee **STEP 1 Symmetrix STEP 2 Satromizer** (CHAPTER 9) **STEP 3 FotoMuse** (CHAPTER 3) **STEP 4 DXP** (CHAPTER 2)

 Symmetrix allows you to use a mirror effect to create a symmetric image. Although this sounds somewhat mundane, the implementation of the app brings it to another level. By scaling, stretching, rotating, and moving vertically or horizontally in a very fluid way, you can achieve some unexpected results. Warning: This app is very low-res.

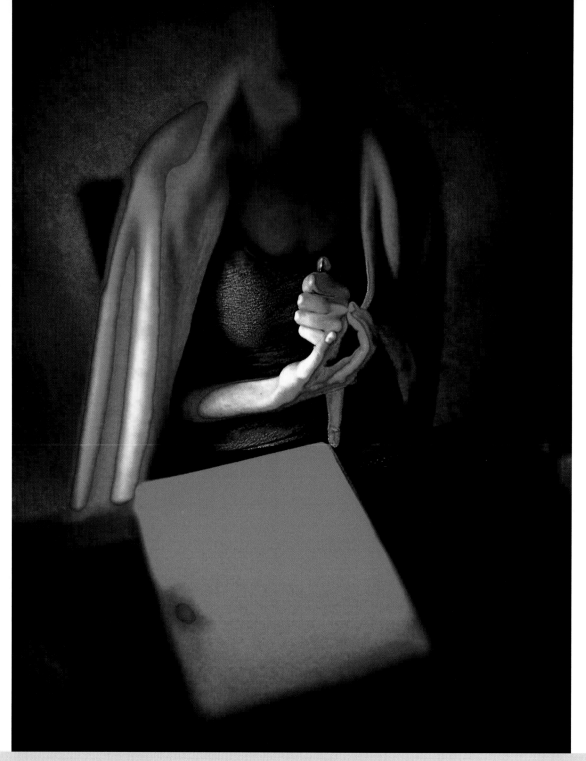

Dana Recharging **STEP 1 Plastiq Camera STEP 2 TiltShift** (CHAPTER 4) **STEP 3 FX Photo Studio**

 Plastiq Camera brings your images dreamy film and lens effects like a toy camera. Although slow and a little hit or miss, this app does produce quality effects in some situations. I especially like the Polarius effect—it feels more like a Polaroid than what a lot of the other Polaroid apps produce.

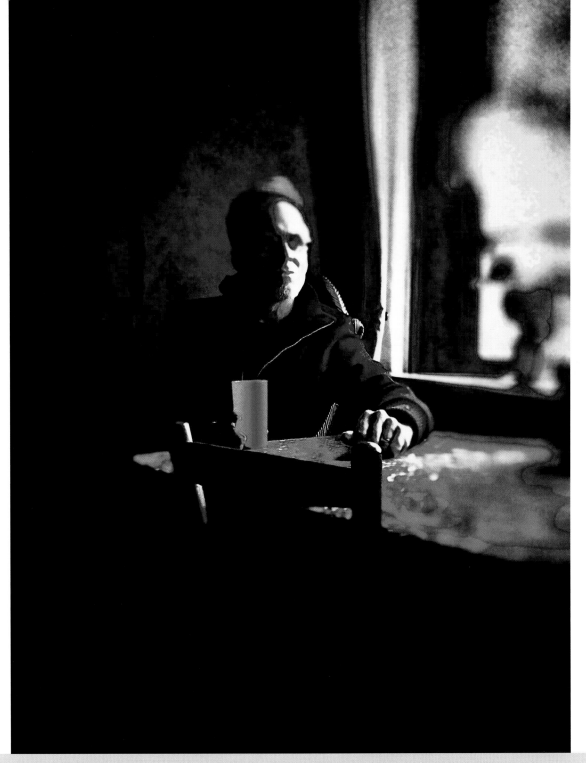

The Mill Keeper **STEP 1 ProHDR** (CHAPTER 8) **STEP 2 Bad Camera** **STEP 3 FX Photo Studio**

 FX Photo Studio is a powerhouse of over 181 image effects. Although many are cheesy, some are truly unique, like Amsterdam (which was used on these two images). But even better than that, you can create, save, and share your own effect by stacking individual parameters together.

Avocado **STEP 1 Hipstamatic** (CHAPTER 6) **STEP 2 FluidFX STEP 3 SketchMee** (CHAPTER 7) **STEP 4 Sketch Club STEP 5 DXP** (CHAPTER 2)

 Sketch Club is a procedural-brush-drawing app. If you have never tried drawing with a procedural brush you will be surprised. It seems to draw for you—it gives your strokes instant style and honesty. This is my favorite app of this type, as you have lots of control and options. Most important, you can bring in an image to trace over.

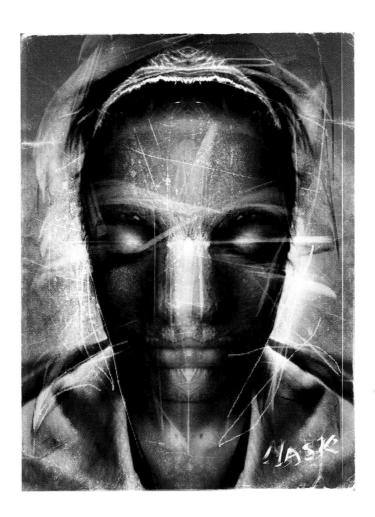

Masked **STEP 1 ArtistaOil** (CHAPTER 7) **STEP 2 PictureShow** (CHAPTER 11) **STEP 3 Sketch Club STEP 5 Photoshop** (DESKTOP)

Links Glossary

Dedication

 Family Gallery
Here is a small portfolio of images from each of my family members.
APP TAG portal.sliderocket.com/ACUSB/1/

Chapter 2 Straightforward

 Photoshop Express
marcolinaslate.com/obsessed/PhotoshopExpress/

 Iris Studio
marcolinaslate.com/obsessed/IrisStudio/

 DXP
marcolinaslate.com/obsessed/DXPPremium/

 Tiffen PhotoFX
marcolinaslate.com/obsessed/TiffenPhoto/

 Perfectly Clear
marcolinaslate.com/obsessed/PerfectlyClear/

 Touch Retouch
marcolinaslate.com/obsessed/TouchRetouch/

 TouchUp Studio
marcolinaslate.com/obsessed/TouchUpStudio/

 Camera Prep
Scan this tag for a review of the best camera-use techniques and apps.
APP TAG marcolinaslate.com/obsessed/12/

 End of the Hall
Scan this tag to see the process and apps used in creating this image.
TIP TAG marcolinaslate.com/obsessed/17/

Pixelated Whale
Scan this tag to see the process and apps used in creating this image.
TIP TAG marcolinaslate.com/obsessed/18/

Marcolina DSLR
The strength of shooting with a DSLR is usually complex pattern, color, and light with lots of details.
PIC TAG portal.sliderocket.com/ACUSB/21/

Chapter 3 Grunge

 FotoMuse
marcolinaslate.com/obsessed/FotoMuse/

 PicGrunger
marcolinaslate.com/obsessed/PicGrunger/

 PhotoCopier
marcolinaslate.com/obsessed/PhotoCopier/

 Summer's Last Dive
Scan this tag to see the process and apps used in creating this image.
TIP TAG marcolinaslate.com/obsessed/30/

 Avon by the Sea
Scan this tag to see other variations of this scene and other beach related images.
PIC TAG portal.sliderocket.com/ACUSB/33/

 DXP Premium
Scan this tag to download custom textures and borders created by the author exclusively for this book.
PIC TAG marcolinaslate.com/obsessed/41/

Chapter 4 Blurs and Vignettes

 TiltShift
marcolinaslate.com/obsessed/TiltShift/

 BlurFX
marcolinaslate.com/obsessed/BlurFX/

 CameraKit
marcolinaslate.com/obsessed/CameraKit/

 Night-Blooming Cereus
Scan this tag to see the process and apps used in creating this image.
TIP TAG marcolinaslate.com/obsessed/46/

 Community Garden
Scan this tag to see more images from this garden taken over the different seasons.
PIC TAG portal.sliderocket.com/ACUSB/57/

Chapter 5 Toon Looks

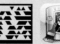 **ToonPaint**
marcolinaslate.com/obsessed/ToonPaint/

 Percolator
marcolinaslate.com/obsessed/Percolator/

 ArtistaHaiku
marcolinaslate.com/obsessed/ArtistaHaiku/

 Barbie's Dream House
Scan this tag to see the process and apps used in creating this image.
TIP TAG marcolinaslate.com/obsessed/60/

 Window Dressing
Scan this tag to see the process and apps used in creating this image.
TIP TAG marcolinaslate.com/obsessed/70/

Chapter 6 Film Looks

 PlasticBullet
marcolinaslate.com/obsessed/PlasticBullet/

 FilmLab
marcolinaslate.com/obsessed/FilmLab/

 Hipstamatic
marcolinaslate.com/obsessed/Hipstamatic/

 Afternoon Mirror
Scan this tag to see the process and apps used in creating this image.
TIP TAG marcolinaslate.com/obsessed/74/

 Magic Bullet
See our broadcast video work, including examples where Magic Bullet was used.
TIP TAG portal.sliderocket.com/ACUSB/76/

 Dana in No Exit
Download a reference file showing almost every Hipstamatic film and lens combination.
TIP TAG marcolinaslate.com/obsessed/89/

Chapter 7 Painting Looks

 Artist'sTouch
marcolinaslate.com/obsessed/ArtistsTouch/

 ArtistaOil
marcolinaslate.com/obsessed/ArtistaOil/

 SketchMee
marcolinaslate.com/obsessed/SketchMee/

 Endless Summer
Scan this tag to see the process and apps used in creating this image.
TIP TAG marcolinaslate.com/obsessed/93/

 Parking Garage
Scan this tag to see the process and apps used in creating this image.
TIP TAG marcolinaslate.com/obsessed/96/

 SneakyPix
Scan this tag to see some apps that allow you to take pictures without being obvious.
TIP TAG marcolinaslate.com/obsessed/99/

 Full-Body Portraits
Scan this tag to see the process and apps used in creating this image.
TIP TAG marcolinaslate.com/obsessed/103/

Chapter 8 High Dynamic Range

 ProHDR
marcolinaslate.com/obsessed/ProHDR/

 TrueHDR
marcolinaslate.com/obsessed/TrueHDR/

 HDR Extras
Scan the tag to see some apps and accessories to help take better HDR images.
TIP TAG marcolinaslate.com/obsessed/111/

 Beach Boulevard
Scan this tag to see the process and apps used in creating this image.
TIP TAG marcolinaslate.com/obsessed/114/

Chapter 9 Breakouts

 Diptic
marcolinaslate.com/obsessed/Diptic/

 QuadCamera
marcolinaslate.com/obsessed/QuadCamera/

 LoFi
marcolinaslate.com/obsessed/LoFi/

 Andigraf
marcolinaslate.com/obsessed/Andigraf/

 addLib
marcolinaslate.com/obsessed/addLib/

 Cubism
marcolinaslate.com/obsessed/Cubism/

 Satromizer
marcolinaslate.com/obsessed/Satromizer/

 Church and State
Scan this tag to see the process and apps used in creating this image.
TIP TAG marcolinaslate.com/obsessed/118/

 Old Retreads
Scan the tag to see a few movies (GIF animations) created with this app.
TIP TAG portal.sliderocket.com/ACUSB/122/

 Catholic School Days
Scan this tag to see the process and apps used in creating this image.
TIP TAG marcolinaslate.com/obsessed/124/

Chapter 10 Adding Light

 LensFlare
marcolinaslate.com/obsessed/LensFlare/

 Light
marcolinaslate.com/obsessed/Light/

 LightLeak
marcolinaslate.com/obsessed/LightLeak/

 Surf City
Scan this tag to see the process and apps used in creating this image.
TIP TAG marcolinaslate.com/obsessed/134/

 CameraSync/Transfer
Learn how to bring in other source photos and how to keep your images safe.
APP TAG marcolinaslate.com/obsessed/141/

Chapter 11 Auto Effects

 PictureShow
marcolinaslate.com/obsessed/PictureShow/

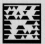 **LoMob**
marcolinaslate.com/obsessed/LoMob/

 CameraBag
marcolinaslate.com/obsessed/CameraBag/

 Napa Reflections
Scan this tag to see the process and apps used in creating this image.
TIP TAG marcolinaslate.com/obsessed/151/

 Toy Cameras
Scan this tag to see an image collection shot with toy cameras and real film.
APP TAG portal.sliderocket.com/ACUSB/155/

Chapter 12 Parting Shots

 Coming to iTunes
The iPhone Obsessed iPad Companion app features interactive demonstrations from this book.
APP TAG portal.sliderocket.com/ACUSB/162/

 Bad Camera
marcolinaslate.com/obsessed/BadCamera/

 PinHole Camera
marcolinaslate.com/obsessed/PinHoleCamera/

 Filterstorm
marcolinaslate.com/obsessed/Filterstorm/

 FluidFX
marcolinaslate.com/obsessed/FluidFX/

 AutoStitch
marcolinaslate.com/obsessed/AutoStitch/

 TimeTracks
marcolinaslate.com/obsessed/TimeTracks/

 Symmetrix
marcolinaslate.com/obsessed/Symmetrix/

 Plastiq Camera
marcolinaslate.com/obsessed/PlastiqCamera/

 FX Photo Studio
marcolinaslate.com/obsessed/PhotoStudio/

Sketch Club
marcolinaslate.com/obsessed/SketchClub/

Index

Acknowledgments

I would like to thank my talented team at Marcolina Design—Laura Kicey and Brandon Troutman—for all their inspiration and production help to make this beautiful book. Also to the team at Peachpit for guiding my words and design through the mysterious book realm. Special thanks to my surfing and photography pal Paul Schoenberger, who appears on the front cover, for his great ideas and ready assistance. And to all the talented photo app producers who have opened a flood of image possibilities. Finally, my parents who helped get me here.

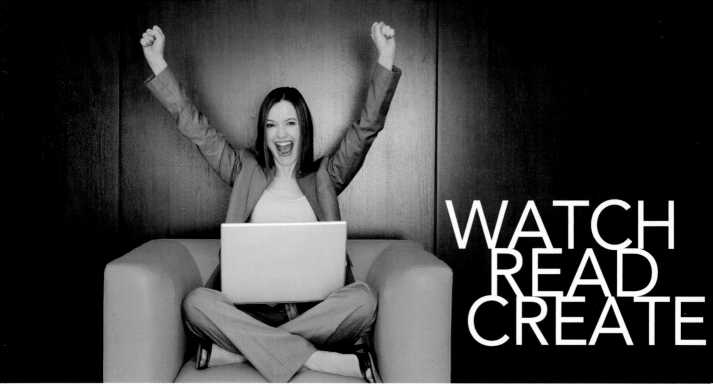